IMAGES
of Modern America

FIRE ISLAND

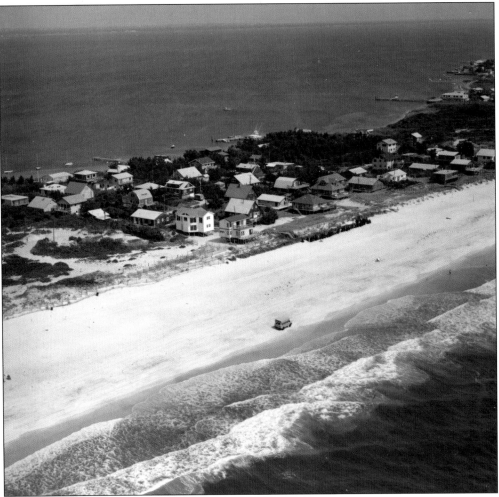

A school bus drives along the beach on the west of Fire Island around 1983. While automobile use is largely restricted due to Fire Island National Seashore driving regulations, an exception is the transportation of resident schoolchildren from pre-kindergarten right up through high school graduation. (Courtesy NPS, Fire Island National Seashore.)

ON THE FRONT COVER: Clockwise from top left: The *Voyager* (courtesy Lani Aughenbaugh; see page 43), sunfish on the Great South Bay (courtesy Appalachian Mountain Club; see page 47), Fire Island Lighthouse (courtesy Vicki Jauron; see page 20), Patersquash Gun Club being washed away (courtesy Mike Busch; see page 76), Farley children with a friend in the bay (courtesy Mary Farley; see page 47).

ON THE BACK COVER: From left to right: Aerial view of the breach at Old Inlet (courtesy Diane Abell, National Park Service; see page 84), lovers on the beach (Lani Aughenbaugh; see page 93), Dwyer children on the beach (courtesy Eileen Dwyer Larsen; see page 14).

IMAGES

of Modern America

FIRE ISLAND

Shoshanna McCollum

ARCADIA
PUBLISHING

Published by Arcadia Publishing
Charleston, South Carolina

Printed in the United States of America

Library of Congress Control Number: 2013952058

For all general information, please contact Arcadia Publishing:
Telephone 843-853-2070
Fax 843-853-0044
E-mail sales@arcadiapublishing.com
For customer service and orders:
Toll-Free 1-888-313-2665

Visit us on the Internet at www.arcadiapublishing.com

In memory of my aunt Alma Schwartz, for her love of words.

CONTENTS

ACKNOWLEDGMENTS

Families from all over the country contributed pictures from their private collections toward this effort, as did some of the finest professional photographers working on Long Island today. Working with all of them has been an honor. Please take note of the photographic credits and consider visiting the websites when cited. The public outreach efforts of Marshall Brown, president of Save the Great South Bay, Cait Russell of LongIsland.com, and Liz Finnegan of the *Islip Bulletin* proved indispensable in getting us all together. Special thanks go to the men and women who agreed to have their portraits taken for inclusion in this book, as well as Kathryn Johnson of the Point O' Woods Archives; Nancy Solmon, president of Long Island Traditions; columnist Karl Grossman; cartographer Paul Pugliese; and the Barbash family for providing essential background information. And fondest appreciation goes to the staff of Fire Island National Seashore. Decades of FINS file photographs compose the backbone of this work, and they are credited by the abbreviation NPS.

INTRODUCTION

"Whatever you do, don't show pictures of sunsets," cautioned Secretary of the Interior Stewart Udall to Murray Barbash the day he testified before Congress. In the early 1960s, Barbash, as president of the Citizens' Committee for a Fire Island National Seashore, was speaking before the lawmakers of the land. Udall's words may sound like sacrilege, but Barbash understood the message immediately: Sentimentality would not win the day.

The threat of development was nothing new to Fire Island. At the prospect of the virgin primeval woodland being extinguished by developers in 1952, a forward-thinking couple by the name of Dunlop founded Wildlife Preserves Incorporated. This modest organization acquired land parcels in the Sunken Forest to keep them pristine. The fight to save the forest foreshadowed events to come.

In 1962, a historic nor'easter known as the Ash Wednesday Storm wreaked havoc along Fire Island's oceanfront. Damage of such scale had not been witnessed there since the Hurricane of 1938. Long Island State Parks commissioner Robert Moses had long been anxious to build a highway on Fire Island, and he seized the Ash Wednesday Storm as his opportunity to do it. Another citizenry might have been more complacent, but not the people of Fire Island.

Babylon-based attorney and Dunewood resident Irving Like methodically approached the problem as a civil matter. He learned of the 1955 Atlantic and Gulf Coast Shoreline survey by the National Park Service that identified Fire Island as one of the most important undeveloped shoreline areas in the eastern United States and, therefore, a prime candidate for national seashore declaration. Soon, the Citizens' Committee for Fire Island National Seashore took shape. Every Fire Island community had a representing liaison, and there were also partners from beyond: Federation of New York State Bird Clubs, various chambers of commerce, the town boards of Islip and Brookhaven, and many others. This was not just a Fire Island effort anymore.

Six separate bills on the subject had been introduced between 1958 and 1964. The original boundaries for the proposed national seashore spanned 52 miles, stretching between Fire Island Inlet and the village of Southampton. This did not go over well, and the scope was subsequently reduced. Then, a woman by the name of Priscilla Roe, representing the Suffolk County League of Women Voters, petitioned Congress to amend the Fire Island bill to include a "no-roads" amendment. This addition stalled bill approval until it almost died before leaving committee. Some congressmen admonished Roe for meddling in government affairs. "I can take care of my enemies. God protect me from my friends," said Democratic New York representative Otis G. Pike, according to a *Newsday* article of the era penned by Don Smith. "If she had come to me, I would have pleaded with her to leave things alone. The bill was going well."

However, Roe had the foresight to recognize that, without such a provision, the Citizen's Committee might be successful in preventing Robert Moses from laying his highway, but would be powerless to stop another entity from building a road in the future, especially once the island was under federal jurisdiction. Her insistence on this point kept the bill's integrity intact when Pres. Lyndon Johnson finally signed it into law.

It is remarkable that in a nation so enamored with automobile driving, Fire Island's cause took on the momentum that it did. Maybe the rapid postwar development of Long Island raised collective consciousness that some places had to be set aside before it was too late.

Waterborne transportation for Fire Island via a system of private ferry companies had existed for many decades. Private boats were also an easy fit. Southern New York is a collection of islands, after all, so residents of greater Long Island handle and enjoy their watercraft with ease.

However, it is a myth that Fire Island is "automobile free." They are important here, just as they are elsewhere. The labyrinth of regulations that surround automobile driving on Fire Island has become very complex. Fire Island National Seashore does bestow driving permits, but they come with caveats. These permits allow the small year-round population to manage during the off-season—nine months out of the year when frequent ferry service is not to be had. The number of trips one can take on and off the island per day are limited, and in the summer, year-round residents must ride the ferry like everyone else. There is also a strict cap on how many resident permits are allowed island-wide. The much-coveted driving permit has on occasion been the source of fraud and bitterness between neighbors. This strange ripple is certainly something the passionate community activists who pursued a national seashore never anticipated.

Another specter with which Fire Island contended has been coastal flooding and beach erosion. The area may have a few good years, then it gets hit hard again. The pendulum swings. Through it all, a legacy even older than Fire Island National Seashore itself is a US Army Corps of Engineers study called the Fire Island to Montauk Point Reformulation Plan (FIMP.) With origins dating to the Eisenhower administration, this study without end, the funding of which could have financed actual beach nourishment projects several times over, has long vexed Fire Islanders. It has made them testy when experts speak before them full of rhetoric. It has enraged them when firsthand observations are casually dismissed. Yet, with that said, obstinance has not always served the Fire Islander particularly well.

In the wake of another historic storm, Fire Island finds itself at a crossroads again. Confidence has faltered, and the destiny of Fire Island's future is uncertain. Conflicts and squabbles that have inevitably arisen over the past 50 years seem petty and small. Hurricane Sandy could be Fire Island's curse, or its greatest blessing, depending on what residents choose to make of it.

After the Hurricane of 1938, things were done differently on Fire Island. Communities like Saltaire and Cherry Grove, which once saw fit to bulldoze their dunes to get better views of the ocean, realized this was not a great idea. The Grove now has what many consider to be one of the best-managed dune districts on the island. Instead of ushering in the end for Fire Island, 1938 became a symbol of fortitude and resilience.

In this spirit, Sandy should be viewed as a moment for self-assessment, to perhaps right some wrongs. This is an opportunity that must not be squandered by those who would exploit a natural disaster for personal gain. In the 1990s, Ocean Beach had a modest lifeguard shack on the beach. By 2011, it had evolved into a sprawling compound that cut dangerously deep into the dune line. To build its exact replica would mean we failed to come away with lessons learned.

The photographers who chose to contribute to this book come from all parts of the country, testament to the fact that being a Fire Islander means more than a mere property deed. Fire Island belongs to us all. So, let us break away from Stewart Udall's stodgy rule and maybe even include a photograph of a sunset or two.

One

GOLDEN AGE

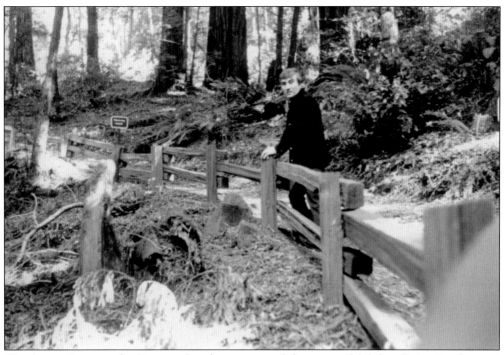

"By chance I saw in the *Times* today the account of the successful fight of Mrs. Dunlop and yourself to preserve the Sunken Forest," author Herman Wouk wrote to James N. Dunlop on July 5, 1955. "I sometimes think that it is by such little-noticed actions for the public good that the world is held together." Here, Mike Ceraso stands in the Sunken Forest around 1984. (Courtesy Ceraso/Macri family.)

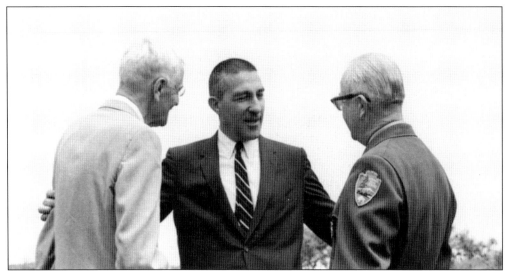

"John Lindsay's bill pertaining to Fire Island has little or no chance of success," wrote philanthropist Ward Melville to James Dunlop on September 21, 1962. "The National Park Service would take over some five separate parcels interspersed with private holdings. The total of them all might add up to less than 3,000 acres. . . . Lindsay's bill is not likely to be taken seriously." In the above photograph, taken in 1966, James Dunlop (left) is seen with Secretary of the Interior Stewart Udall (center) and Henry Schmidt, the first FINS superintendent. Below, Mary Ann Fitzgerald and Billy Michael, pictured in the Sunken Forest 20 years later with their children Molly and William Jr., prove Melville's hypothesis incorrect. (Above, courtesy NPS; below, courtesy McCollum family.)

"'Mr. Moses called and is very upset with you,' the publisher said. 'You're fired.' That's how I lost my first job as a reporter," writes syndicated columnist Karl Grossman (above), reminiscing in the *Shelter Island Reporter* article "Suffolk Closeup: Taking on Mr. Moses" about one of his first newspaper jobs with the *Babylon Town Leader*. "It was an uphill battle. Hardly any elected officials would say or do anything in opposition to Mr. Moses. He also seemed to have the big daily newspapers of the area in his pocket. They pushed hard for the road. . . . A Citizens Committee for a Fire Island National Seashore was formed and was highly effective. U.S. Interior Secretary Stewart Udall paid a visit and embraced the seashore idea." (Above, courtesy Karl Grossman; below, courtesy NPS.)

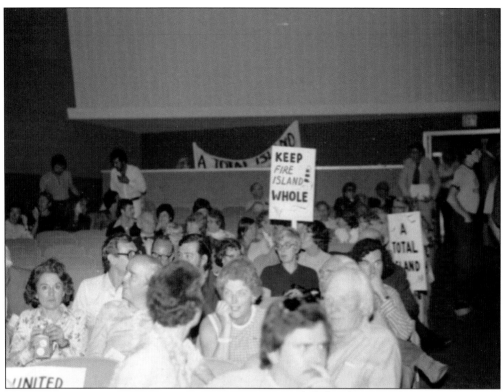

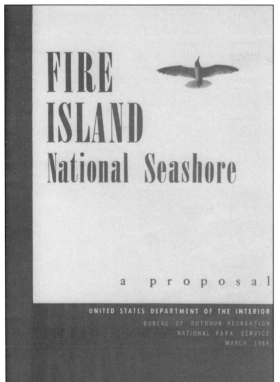

While local support for a Fire Island National Seashore emerged from grassroots efforts, National Park Service policy toward this trend had been building for quite some time. A 1955 NPS Atlantic and Gulf Coast Shoreline survey identified Fire Island as "one of the most important remaining undeveloped shoreline areas in the eastern United States." In short, Congress recognized that this was not simply a local matter. Indeed, the creation of a national seashore in such proximity to the metropolis of New York City was of national interest. (Above, courtesy NPS; below, courtesy Lillian Barbash.)

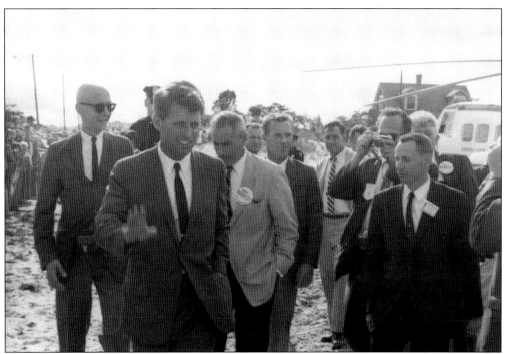

While not a direct player in the establishment of Fire Island National Seashore, Robert Kennedy took an interest in the cause, as his influential family had supported a similar matter in Cape Cod a few years before. Fire Island was a subsequent presidential campaign stop for Kennedy, and he made a dramatic helicopter landing in the ball field at Corneille Estates (above). By 1972, Marian and Charles Stack (below) would enjoy their budding courtship along the shores at Ocean Bay Park. The creation of Fire Island as a national seashore cannot be credited to one sole powerbroker. (Above, courtesy Loeffler family; below, courtesy Patricia Stack.)

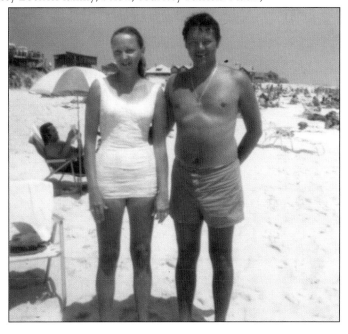

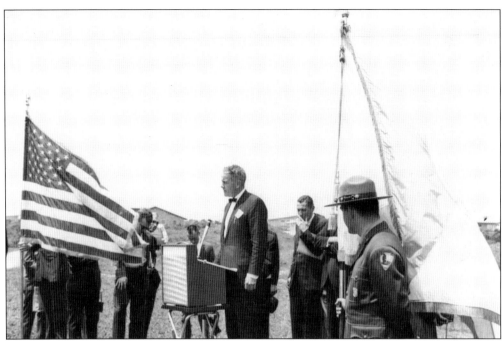

On September 11, 1964, President Johnson signed the legislation to create Fire Island National Seashore. There had been some false starts, but these had largely been due to technicalities of size and scope regarding the boundaries of this new national park. The Dwyer children (below) were not aware of all these changes when they played on the beach in 1964, but Fire Island's modern era had begun. Pictured above is US congressman Otis Pike at Watch Hill Visitor Center's ground-breaking ceremony two years later. "The years have gone by," Karl Grossman writes. "Fire Island remains, a national treasure preserved." (Above, courtesy NPS; below, courtesy Eileen Dwyer Larsen.)

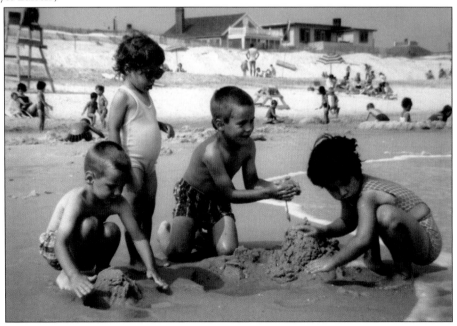

Two

PARK BY THE SEA

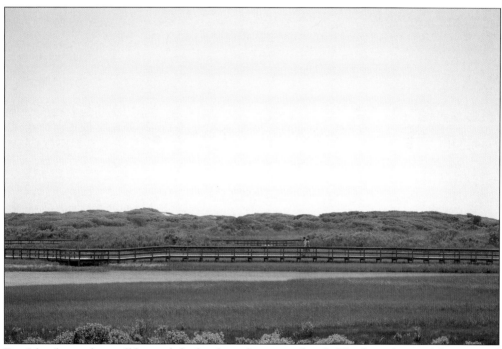

Fire Island stretches well beyond the borders of a national park. The boundaries of the national seashore encompass 26 miles, but the barrier island known as Fire Island is 32 miles in length. Within the boundaries are world-famous beaches and parks much beloved by the residents of Long Island, including Watch Hill, as well as a bounty of residential communities that predate the enacting legislation. (Photograph by Danielle Hundt.)

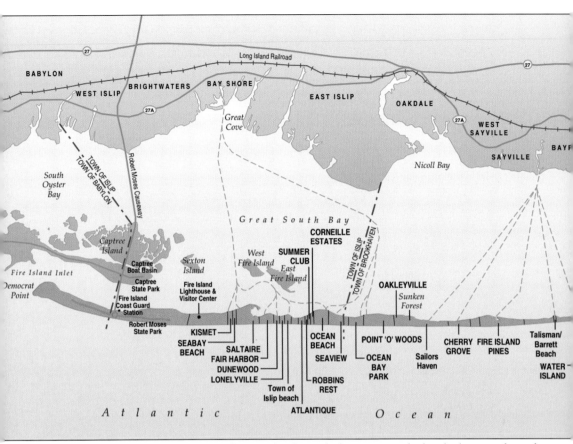

Fire Island's unique shape has buffered Long Island's south shore against the harsh elements through the ages. Like all barrier islands, it is a dynamic formation constantly changing, as dictated by the

16

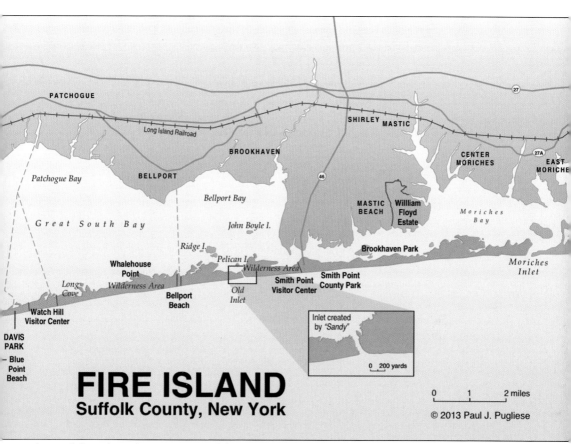

PATCHOGUE

Long Island Railroad

SHIRLEY MASTIC

BROOKHAVEN

27

27A

Patchogue Bay

BELLPORT

CENTER
MORICHES

EAST
MORICHE

Bellport Bay

46

*Moriches
Bay*

MASTIC
BEACH

Willliam
Floyd
Estate

G r e a t S o u t h B a y

John Boyle I.

Ridge I.

Brookhaven Park

*Moriches
Inlet*

Whalehouse
Point

Pelican I.

Wilderness Area

Smith Point
County Park

*Long
Cove*

Wilderness Area

*Old
Inlet*

Smith Point
Visitor Center

Bellport
Beach

Watch Hill
Visitor Center

Inlet created
by "Sandy"

DAVIS
PARK

Blue
Point
Beach

0 200 yards

FIRE ISLAND
Suffolk County, New York

0 1 2 miles

© 2013 Paul J. Pugliese

force of the tides. Thus, any map of the area is a snapshot in time. (Courtesy Paul Pugliese.)

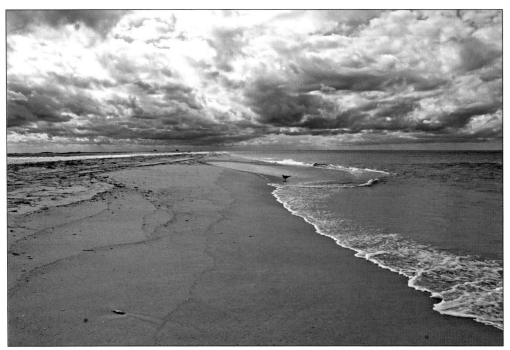

Democrat Point is the island's westernmost tip, at the mouth of Fire Island Inlet. Formed largely over the past century by the process known as littoral drift, in which sand travels from east to west, pushed by the ocean currents. It is among the youngest landmasses on the barrier island, thus contributing to its barren appearance. The drift is an ongoing process, but an engineered jetty and dredging keeps the navigational channel open. Accessible by four-wheel drive and with New York State–issued recreational permit only, Democrat Point is popular for its fishing and surfing. (Above, photograph by Diane Abell, DustyDogDigital.com; below, photograph by Catherine Corssen.)

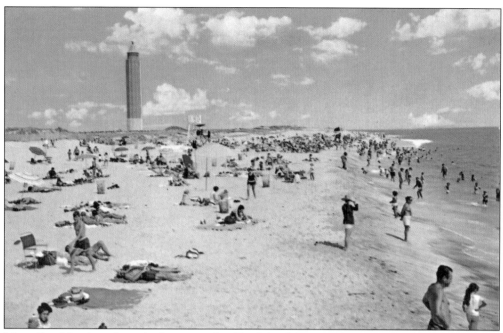

Many Fire Island residents find it ironic that Fire Island State Park was renamed after their great adversary in 1964. Different views of Robert Moses State Park are just as incongruous. Above, this vintage Milt Price postcard of a bustling beach exemplifies the Master Planner's vision of what a public beach in proximity to large urbanized areas should be. Yet it is a vista of pure serenity when seen from the Great South Bay, below. This state-owned portion of Fire Island on its west end attracts 3.5 million visitors a year. The iconic water tower, nicknamed "the Pencil," is a prominent landmark in the area. A few hundred yards east, the paved road comes to an abrupt halt, making this the only western point with full public vehicular access. (Above, courtesy McCollum family; below, photograph by Peter Schmidt, SWAMPonline.com.)

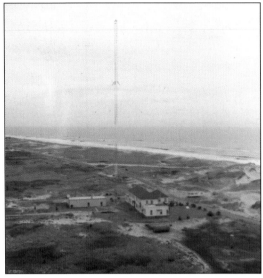

The US Coast Guard station has stood at its present bayside location, between Robert Moses State Park and Fire Island Lighthouse, since 1932. Station Fire Island's primary functions today are search and rescue, law enforcement, and environmental protection of the Great South Bay and local Atlantic waters. (Courtesy NPS.)

Fire Island Lighthouse marks the western boundary of FINS. Its tapered elegance makes it arguably one of the most beautiful lighthouses in the country. Serving as testament to the deep roots of Long Island's maritime heritage, it remains a favorite photograph location for tourists and locals alike. (Photograph by Vicki Jaroun, Babylon and Beyond Photography.)

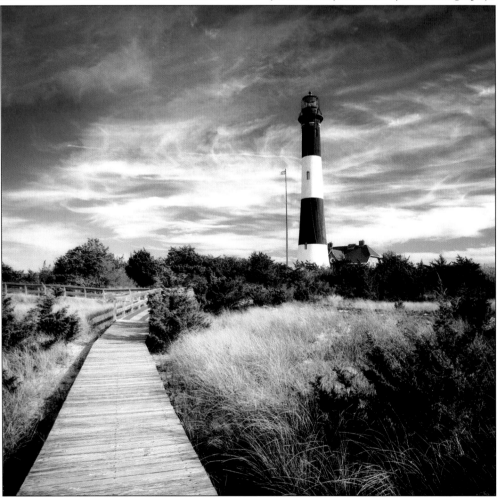

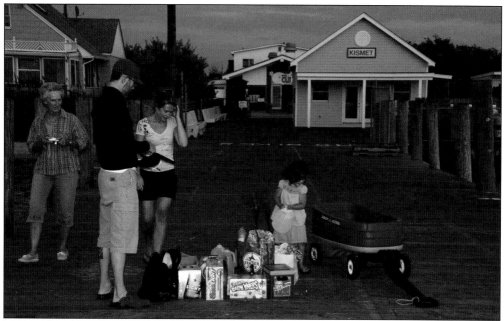

Kismet is the first of the 17 residential communities listed, from west to east, in the FINS enacting legislation's recognition clause. Having had a solid reputation as a singles "grouper" community in the 1970s and 1980s, Kismet has yielded to more family traffic with time's changing trends. (Photograph by Peter Schmidt, SWAMPonline.com.)

Saltaire offers tree-lined tranquility in all seasons. The smaller of two incorporated villages on Fire Island, it is self-governing, with a yacht club, children's day camp, stately houses, and two churches. What it does not have are commercial interests that could disturb the quiet enjoyment of its residents. (Photograph by Warren McDowell.)

Fair Harbor and Dunewood share certain affinities. While Fair Harbor does have a small commercial strip that includes a restaurant and ice-cream stand (above), these amenities complement the community's quiet lifestyle, not compete with it. The developers of Dunewood, taking cues from past conflicts between commercial and residential districts in other Fire Island communities, built a "grouper and commercial-free" enclave. The only fully planned Fire Island community, Dunewood has very few homes that resemble their original stock appearance. Both communities take pride in their recreational boating lifestyle, with Dunewood's sailing regatta (below) a popular local event. (Above, photograph by Jonathan Milenko; below, photograph by Ellen Abramowitz.)

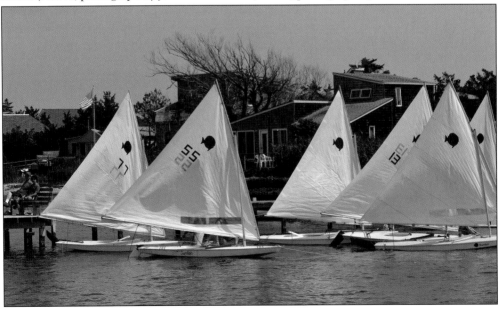

Lonelyville and Atlantique have in common their diminutive size and rustic terrain. Yet life keeps a simple charm in Lonelyville even during the busy summer months, while the Atlantique Beach Marina brings the crowds and exuberant energy of a boating public. This large municipal marina, owned and operated by the Town of Islip, is attractive to the people of Long Island for all the recreational amenities it has to offer. Atlantique is also home to the Appalachian Mountain Club (AMC) beach compound. This is the sole AMC cabin facility in the tristate area, attracting a significant nature-loving patronage. (Above, photograph by Alain Thomas, AlainThomas.net Photography; below, photograph by Catherine Corssen.)

Narrow, undeveloped tracts of FINS property isolate Robbins Rest from its neighbors. A popular hotel and nightspot called the Sand Castle existed in Robbins Rest for many decades. After 1999, the business changed hands several times until it was bought out by silent partners in 2007. This tight-knit community cherishes its peace and quiet. (Photograph by Sharon Fiyalka.)

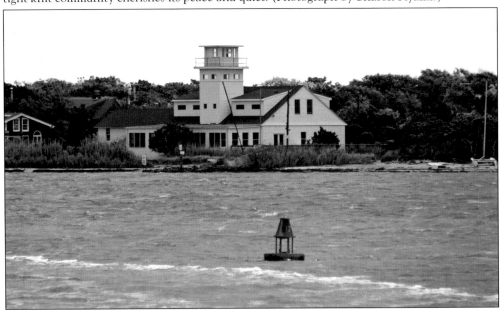

Social life at the Fire Island Summer Club revolves around the distinctive former Coast Guard station that serves as its communal headquarters. Purchased as government surplus from Blue Point Beach in 1946, it was floated west by barge. The building is the last remaining example of a classic lifesaving station on Fire Island. (Photograph by Diane Abell, courtesy NPS.)

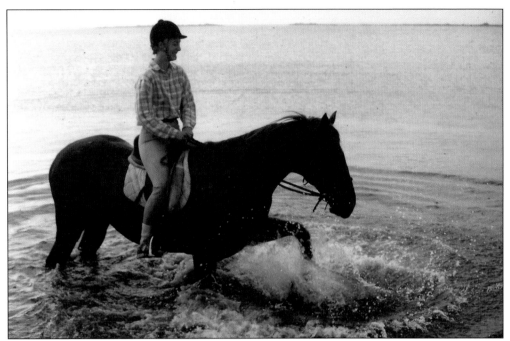

Corneille Estates was once home to stables owned by a racehorse enthusiast named Dana Wallace. He firmly believed that a regimen of shoreline exercise improved the strength and endurance of the horses. The sight of these fine specimens enjoying their time in the water was a vision to behold. (Courtesy Dale Wycoff.)

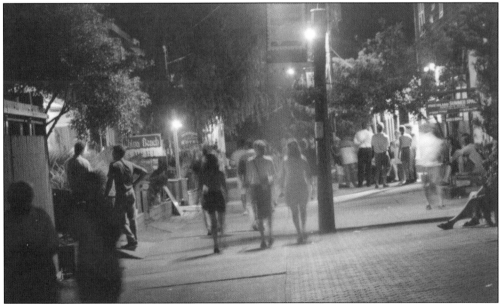

An abundance of hotels, restaurants, and shops makes Ocean Beach attractive to people coming to Fire Island just for the day or longer. The village is densely built, with over 600 homes within one square mile. Featuring streets congested with bicycles and foot traffic in the summer months, Ocean Beach is almost like a small city. It is solidly relied upon for the many services that it offers. (Photograph by Lani Aughenbaugh.)

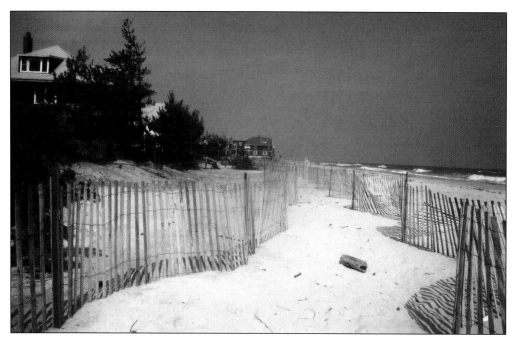

Seaview is a decidedly genteel, well-manicured community with fine examples of architecture among spacious green lots. It has a ball field, tennis courts, and a very smartly designed beach swimming facility. The quieter lifestyle is preferred by its residents over the fast-paced tempo of Seaview's immediate island neighbors. (Photograph by Helga Aschner.)

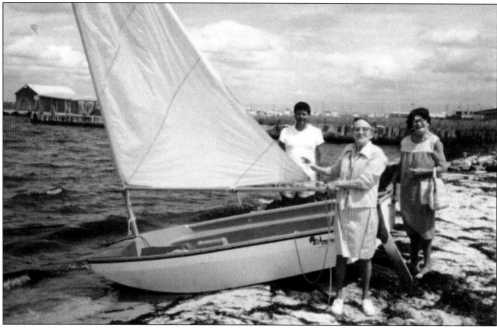

Ocean Bay Park, with hopping bars and an easygoing attitude, has a reputation as a party town. While some have called it "Ocean Beach without rules," Ocean Bay Park has a sturdy backbone of devoted, longtime residents. Shown here are Charles Stack (left), Marian Litt (center), and Ruth Clifford around 1980. (Courtesy Patricia Stack.)

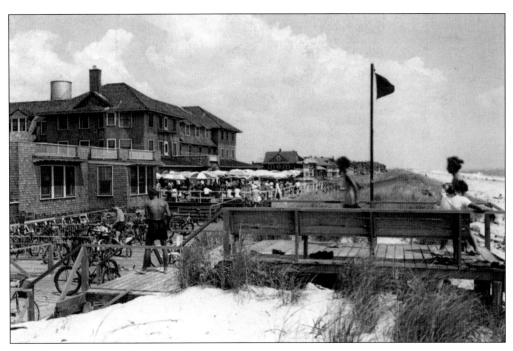

With the Sunken Forest lying in between, one might see the communities of Point O' Woods and Cherry Grove on the extreme ends of the Fire Island spectrum. Above, a vintage Louis Dormand postcard shows the former Point O' Woods Inn. While rustic in appearance, the inn was the emblem of exclusivity, and of the old money and privilege that surrounded it. Cherry Grove's famous Belvedere Guest House (below), a private men's resort of considerable grandeur, was constructed from the found and fanciful. Both communities evolved to pursue their identities as they wished. Indeed, some might argue that such independent spirit of both is the essence of Fire Island. (Above, courtesy Tim Mason collection; below, courtesy Craig Eberhardt, Belvedere Guest House.)

Fire Island Pines is regarded as one of the most glamorous Fire Island communities, and Water Island is seen as among the most private. Chic architecture, exotic landscaping, and wild nightclub parties are often associated with the Pines, but Mike Ceraso's beach house, seen above in 1984, reflects a more low-key aspect. Water Island, pictured below, is one of the last places on Fire Island where acquisition of bay-to-ocean property is still possible, if one has the means. While Cherry Grove and Fire Island Pines have long been known for having predominantly gay resident populations, Water Island is now seeing a similar trend emerging in the 21st century, as more same-sex couples seek the solitude and natural beauty this community has to offer. (Above, courtesy Ceraso/Macri family; below, courtesy NPS.)

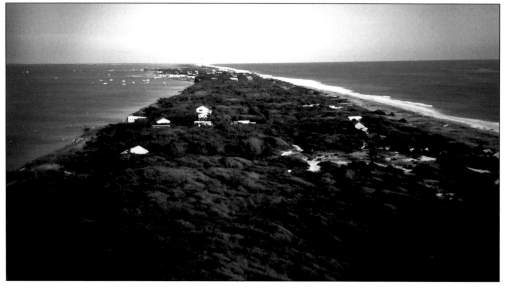

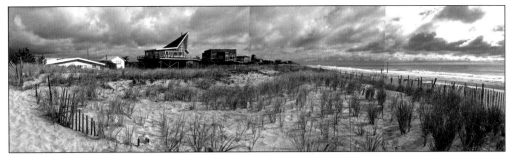

In Davis Park, die-hard populations of recreational boaters occupy the Town of Brookhaven's large public marina, almost a community unto itself. Residential enclaves of Ocean Ridge and Davis Park proper are east and west respectively. The Casino lies in the community's heart as the sole bar and dining establishment. Fire Island National Seashore's Watch Hill and Otis Pike Wilderness Area make for tranquil neighbors. (Photograph by Diane Abell, courtesy NPS.)

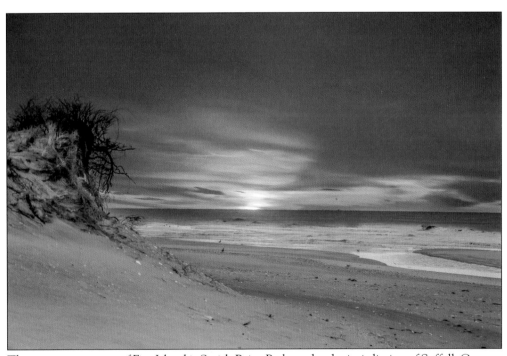

The easternmost part of Fire Island is Smith Point Park, under the jurisdiction of Suffolk County, New York. Accessible from Long Island via the Smith Point Bridge from Mastic Beach, it is the county's largest oceanfront park. Among its amenities are camping and scuba diving. (Photograph by Mike Busch, GreatSouthBayImages.com.)

Enclaves in the area defined as the Seashore District round out this tour. Oakleyville is due west of the Sunken Forest, while Blue Point Beach and Spatangaville (named in honor of Hugo Spatanga) flank Water Island. The 17 communities included in Fire Island National Seashore's recognition clause enjoy considerable autonomy, but the fate of Seashore District areas is less certain. The Seashore acquired the Oakleyville beach house (above) once owned by Metropolitan Museum of Art curator Sam Green shortly after his death in 2011. Similar communities in Fire Island's past, like Skunk Hollow, no longer exist—ultimately condemned by FINS. (Above, photograph by Diane Abell, courtesy NPS; below, photograph by Warren McDowell.)

Three

PEARLS

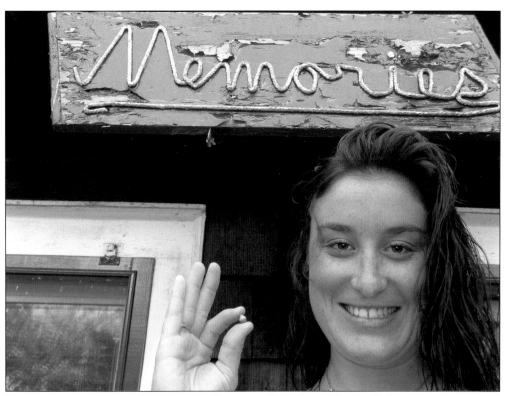

Sixth-generation Fire Islander Katherine Peters stands in front of her family homestead, Memories, holding a Great South Bay pearl. Baymen may find this pearl, produced by the same clams that make wampum, only once in a lifetime. Such is the way of Fire Island culture—rare beauty sometimes where least expected. (Photograph by the author.)

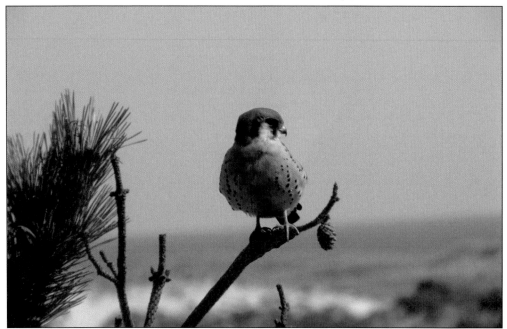

Fire Island is part of the Atlantic Flyway, a vital bird migration route that follows the North American coastline from the Canadian Maritimes to the Gulf of Mexico. The Fire Island Raptor Enumerators (FIRE), a dedicated band of volunteer bird-watchers, arrives with their binoculars and gear to weather the elements as they patiently keep count (below). Birds of prey, including American kestrels (above), hawks, ospreys, and owls, are their primary interest. Data compiled by FIRE over a span of decades has become an important resource in tracking population trends for these magnificent and noble bird species. (Photographs by Gertrude Battaly, courtesy FIRE.)

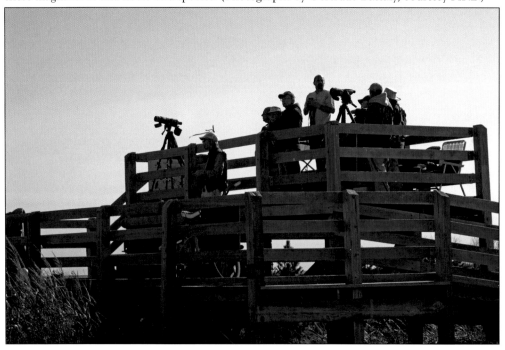

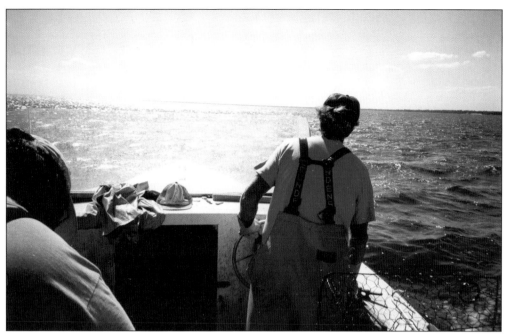

Fishermen who work the waters of the Great South Bay are generally known as baymen. There are families in South Shore, Long Island, that have made fishing these waters their livelihood for generations, harvesting clams, scallops, crabs, and a variety of finfish. The Great South Bay is home grounds of the renowned Blue Point oyster. In the late 1960s, as much as 83 percent of all hard-shell clam production in New York was generated from the Great South Bay. Pictured above is Bob Kaler of Patchogue, New York. (Above, photograph by Steve Warrick; below, photograph by Nancy Solomon; both, courtesy Long Island Traditions collection.)

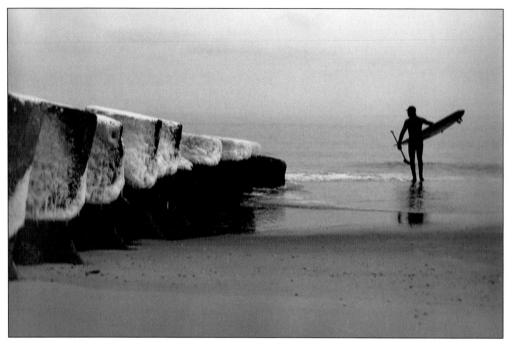

Mention surfing, and beaches in more temperate waters like Hawaii and California come to mind. But Fire Island has a culture of surfing all its own. Natural off-island sandbars and man-made structures like the groins in Ocean Beach, originally constructed to contain beach erosion, are part of the reason why Fire Island board-surfing conditions are desirable. However, this is not Fiji. Fire Island waves are usually better when the weather is brutally cold. Surfing in these waters requires special gear, including full-body wetsuits, as Christopher Brennan (below) skillfully illustrates. (Above, photograph by Doug Meyer Jr.; below, courtesy Christopher Brennan, MD.)

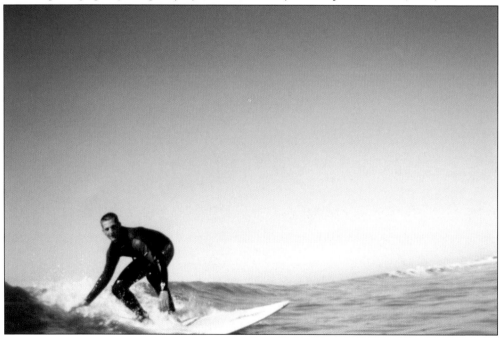

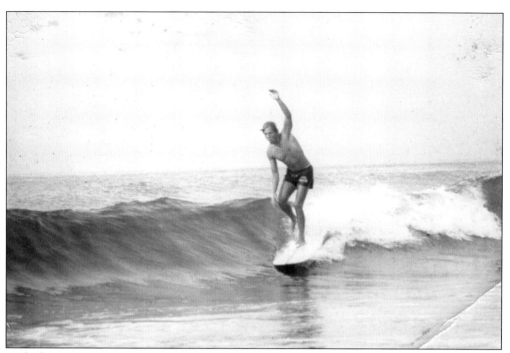

In the late 1960s, Seaview resident Bruce Mayer (above), along with some of his contemporaries, was something of a pioneer when it came to testing the longboard potential of Fire Island's waves. Surfing is a passion he has pursued well into maturity. His nephew Chris has followed in his footsteps. Indeed, surfing in these parts was at one time regarded as a curiosity. But young men and women who have ridden Fire Island's waves all their lives have sometimes gone on to compete nationally and hold their own. Surfing is serious sport here. (Above, courtesy Bruce Mayer; below, photograph by Christopher Mayer, FireIslandImages.com.)

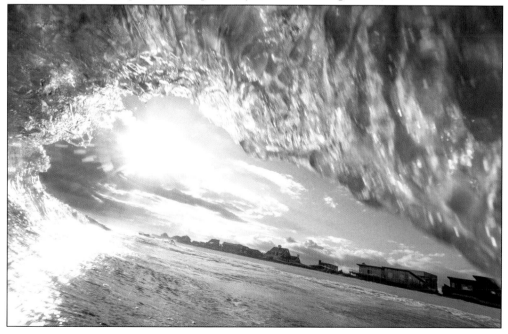

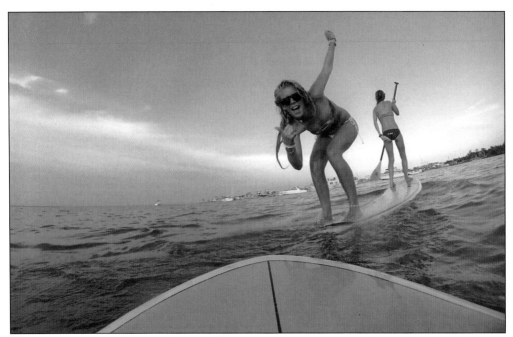

A close cousin to surfing, stand-up paddleboarding has become popular on Fire Island. Also of Hawaiian heritage, it has transitioned into the Fire Island waters with relative ease. Like surfing, it requires superb balance and dexterity, but it can be adapted for enjoyment in calmer waters, while traditional surfing is more dependent on high-wave conditions for optimum experience. Sisters Catherine and Kirsten Corssen (pictured) will be first to attest that water sports of this nature need not be an exclusive men's club. There is room enough for all if the desire is there. (Both, courtesy Catherine Corssen.)

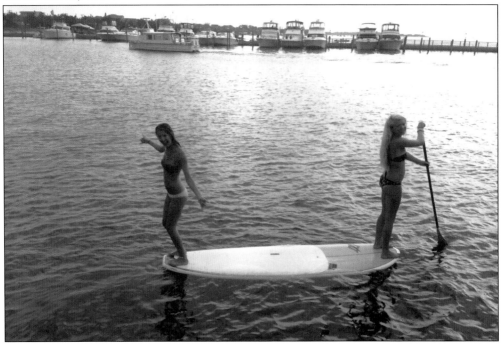

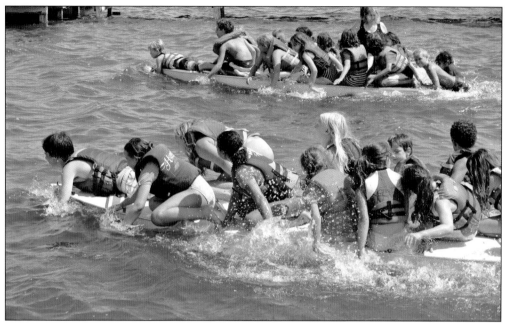

Children's events, like Dunewood's watermelon races (above), establish a lifelong love of water sports on Fire Island. The Maggie Fischer Memorial Great South Bay Cross Bay Swim (below) launches at the Fire Island Lighthouse dock and culminates at Gilbert Park in Brightwaters, New York. This rigorous 5.44-mile swim is not for the faint of heart. Wind and current conditions can make it very challenging. Maggie Fischer, 17, had been a promising athlete, musician, and Village of Saltaire lifeguard when her life was cut short in a car accident just days before she was scheduled to compete in the race in 1999. The annual swim was renamed in her memory and now raises money for charity. The flotilla of kayakers and swimmers is an energetic vision very much enjoyed every summer. (Above, photograph by Ellen Abramowitz; below, photograph by Peter Schmidt, SWAMPonline.com.)

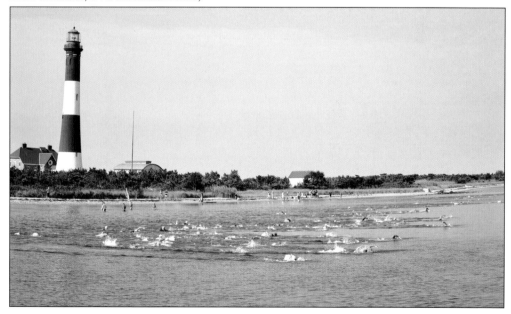

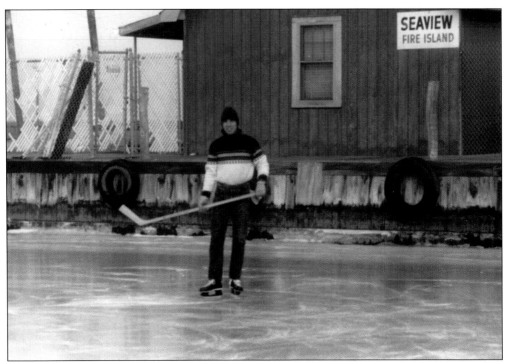

Water sports on Fire Island need not be limited to the summer months. Pictured here in the frozen Seaview ferry basin, Bruce Mayer smiles broadly as he takes advantage of the prime conditions to play a little ice hockey sometime in the 1980s. (Courtesy Bruce Mayer.)

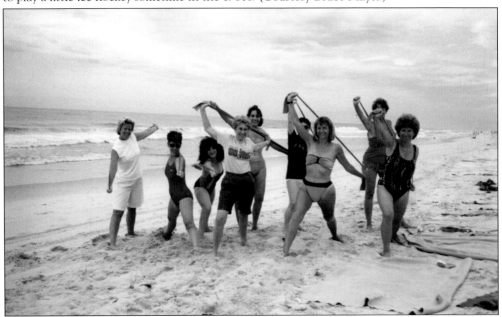

Women from the Appalachian Mountain Club congregate on the beach to practice their yoga moves in the seaside air around 1990. Their enthusiasm is a reminder that good health and vibrancy is a state of mind transcending time, and that bathing beauties are forever young. (Courtesy Appalachian Mountain Club collection.)

Beach strollers may be surprised, or amused, to learn that clothing-optional beaches have been revered among some circles on Fire Island since the 1960s. New York State passed laws prohibiting public nudity in 1984; however, FINS tolerated the practice on federally operated beaches, including Watch Hill, Barrett Beach, Sailors Haven, and Lighthouse Beach. The latter, the closest in proximity to New York City, became one of the most popular nude beaches in the state, if not the country. While in existence for decades, the nude beaches were not officially recognized by FINS policy until 2005. (Above, photograph by Vicki Jauron, Babylon and Beyond Photography; below, photograph by Diane Abell, courtesy NPS.)

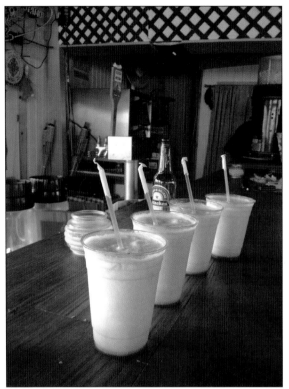

Be it at the Atlantique Concession Shack (left) or a beach party at Corneille Estates, it is fair to say that Fire Islanders enjoy their cocktails. A frozen blender drink known as the Rocket Fuel proudly calls Fire Island home. Invented in a bar in Ocean Beach known as C.J.'s in the 1970s, Rocket Fuel is like a high-octane piña colada, with the important additions of amaretto and 151-proof rum. The drink's popularity quickly spread to other Fire Island watering holes and beyond. The recipe is not difficult. Rick Tafuro, using a gasoline-powered blender and a surfboard, creates a makeshift bar on the beach (below). (Left, photograph by Kirstin Corssen; below, photograph by Theresa Macri.)

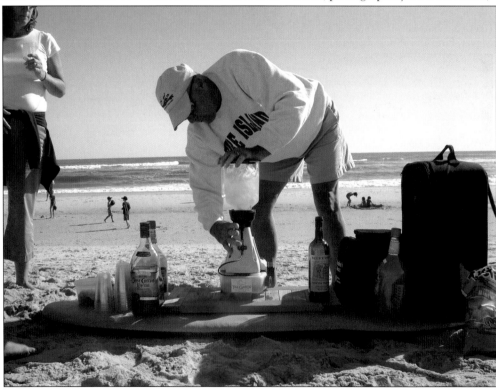

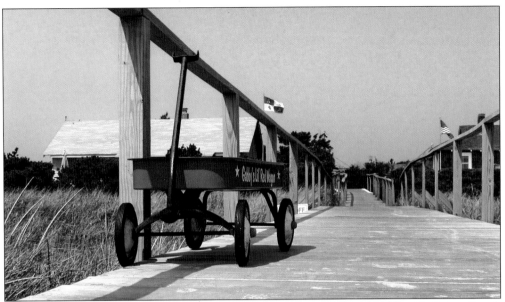

Wagons are synonymous with Fire Island's lifestyle—be it Cherry Grove (above), Ocean Beach (below), or any other Fire Island community—but models change with the times. The classic red Radio Flyer may be the standard which all other wagons are measured against, but any seasoned Fire Islander knows that the harsh salt air corrodes its wheel chassis and, within a couple of summers, it becomes a garden planter. Contemporary plastic models are favored for lightweight durability, but traditionalists lament their inelegant appearance. Janesville's wooden wagons are very much a status symbol, the SUVs of the wagon world. The quest for a better wagon never ceases. (Above, photograph by Diane Abell, DustyDogDigital.com; below, photograph by Christopher Mayer, FireIslandImages.com.)

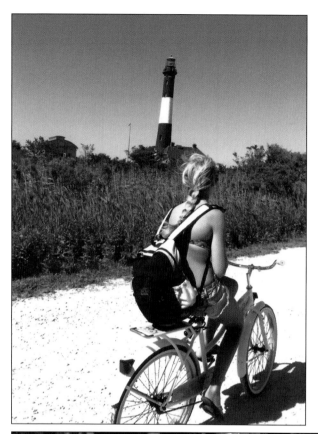

Along with walking, bicycle riding is the predominant mode of transportation on Fire Island. Bikes are used for leisurely rides about town and for brisk commutes to waitressing or lifeguard jobs, as Kirstin Corssen illustrates in the photograph at left. Local police departments on patrol, as well as many volunteer firefighters responding to alarms, also utilize bicycles. In lieu of automobiles, they are second nature in every mode of life. For those who cannot ride a bicycle, adult-sized tricycles, as seen below, are often utilized. Few locals give these contraptions so much as a second glance. (Left, photograph by Catherine Corssen; below, photograph by Vincent Vaughan.)

OCEAN BEACH
VILLAGE EMPLOYEE

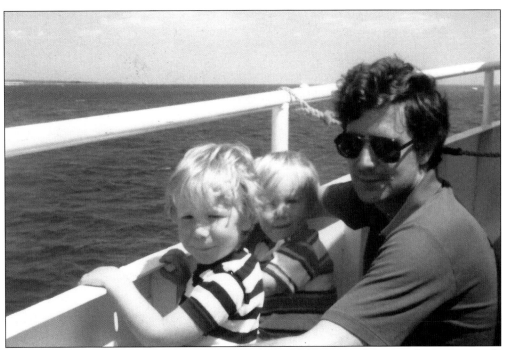

The journey is very much a part of the adventure, and ferries are far more than just a mode of transportation on Fire Island. Restrictions on vehicular driving make waterborne travel a necessity for reaching most parts of it, and often riders embrace the trip as a chance to unwind and connect with friends and family. Weather and crowd conditions can make some trips tougher than others, but Fire Island would not be the same place without these beloved boats. In the above photograph, Jim Fitzgerald rides with his sons Ryan (left) and Kevin around 1981. Below, the *Voyager* comes into port around 1989. (Above, courtesy Mary Ann Dayton-Fitzgerald; below, photograph by Lani Aughenbaugh.)

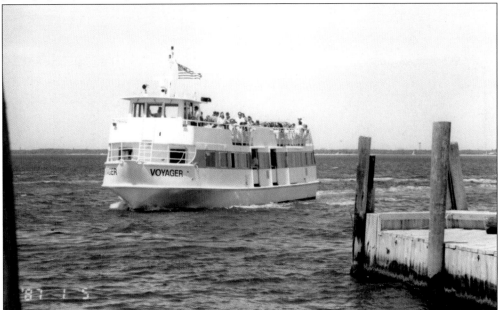

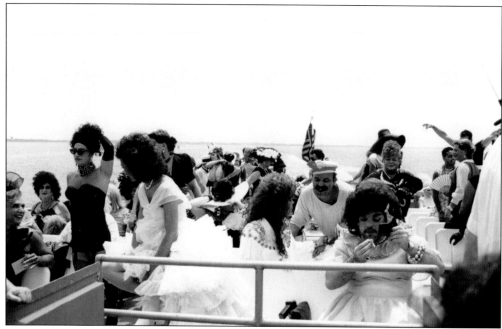

The Fourth of July's Invasion of the Pines parade, marking the start of the high summer season on Fire Island, celebrates Independence Day with a distinct twist. On this day, hundreds of revelers in Cherry Grove pile onto a chartered ferryboat and, dressed in their finest, pay a visit to their sister community, Fire Island Pines, where they are welcomed with open arms. The annual tradition traces its roots from a staged protest in the 1970s, when a bar owner refused to serve a cross-dressing patron. While this day is about spirited good fun, serious issues remain an undercurrent. (Photographs by Warren McDowell.)

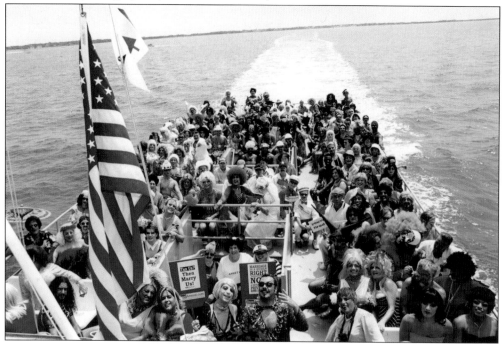

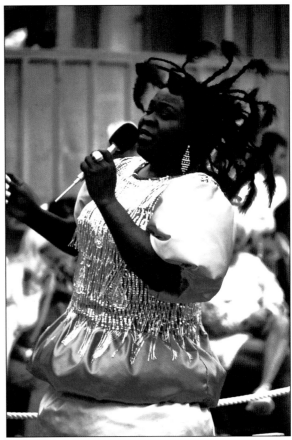

If the Invasion of Fire Island Pines highlights the summer season, the Miss Fire Island Contest, held at the Cherry Grove Hotel on the first Saturday after Labor Day weekend, officially concludes it. Here, style and pageantry are brought to the next level. Glamorous drag queens strut down the runway, and every one of them is beautiful. Inspired by the kitsch of beauty contests like Atlantic City's Miss America Pageant of the 1960s, Miss Fire Island has evolved over the years to include separate categories so that amateurs and mature contestants may compete on equal footing. Winning the crown is a much-sought-after honor. (Photographs by Warren McDowell.)

Local holiday festivities are only one aspect of LGBT life on Fire Island. Rob Liga grew up in Mastic, New York, and earned a commendation medal while serving with the US Army. He purchased his Cherry Grove house overlooking the bay in 2006, shortly before retiring from the New York City Police Department. "I did not want to live a fake life, and my experience with fellow police officers was always positive," says Liga. "When I first learned about Fire Island, I could not believe there was such a place." He met his partner, José Ortiz, in Cherry Grove in the summer of 2008. Pictured above are Rob (right) and José aboard their private boat. Below, they stand on their terrace with Rob's mother, Dorothy, and stepfather, Louis Piacente, who visit regularly, and José's dog, Oscar. (Photographs by the author.)

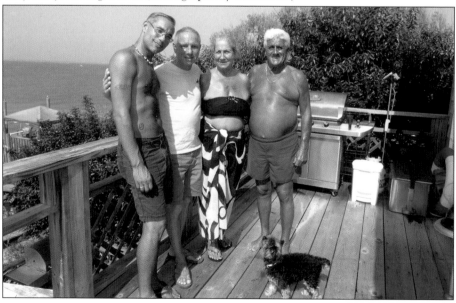

Boating is also a way of life on Fire Island. Long Islanders love their boats, and they gain an affinity for cruising the waters at a very early age. The Farley children grew up in nearby Bay Shore, but vacationed in a number of Fire Island communities, including Ocean Bay Park and Point O' Woods. This photograph of the Farley children, taken in 1967 in the vicinity of Ocean Bay Park, shows, from front to rear, Mary, Jane, Eileen, an unidentified friend, and Billy. (Courtesy Mary Farley.)

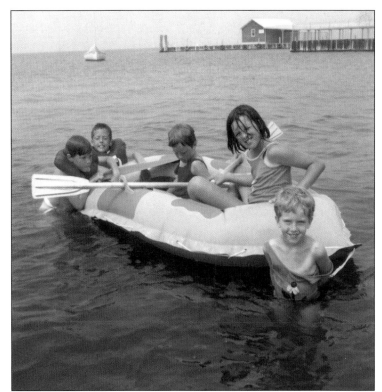

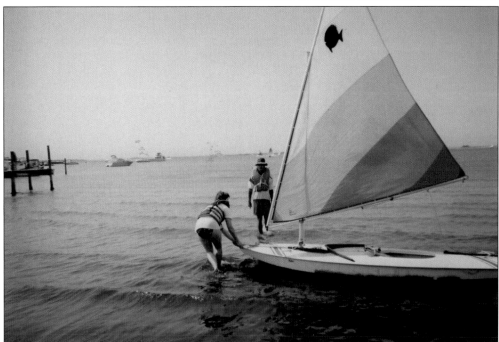

In Atlantique, the Appalachian Mountain Club offers sailing workshops every summer, enabling this sporting tradition to continue to be accessed by all, not just a privileged few. (Courtesy Appalachian Mountain Club collection.)

Most will say that Fire Island is about sharing good times with friends and making memories that will last a lifetime. In the above photograph, three lovely ladies at Watch Hill—Kristina Hundt (left), Erica Corlito (center), and Danielle Hundt—sing their hearts out as they wave their arms in lighthearted celebration. It is Christmas during the Fourth of July at the campgrounds and public marina. Below, Santa, a rabbi, and several little Uncle Sams ride in a motorboat. Gestures such as this make it evident that the concept of a national park for Fire Island was very successful indeed. (Photographs by Danielle Hundt.)

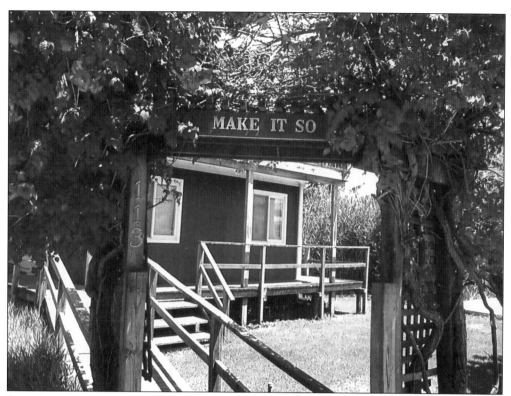

Sometimes, life imitates art. The owners who picked the name for their charming cottage in Kismet (above) took a cue from *Star Trek: The Next Generation*, perhaps because Fire Island makes them feel transported to a better place. Yet, art never seems to tire from taking a page of inspiration from Fire Island's script. Pictured below, a film crew gathers footage in Fire Island Pines for *Garbo Talks*, directed by Sidney Lumet and released in 1984. Filmed on location in Seaview, Frank Perry's 1969 film adaptation of Evan Hunter's *Last Summer* remains a cult classic. However, reality television attempts, like *One Ocean View*, set around Corneille Estates in 2006, flopped miserably. Not all art can match the drama of real life on Fire Island. (Above, photograph by the author; below, photograph by Warren McDowell.)

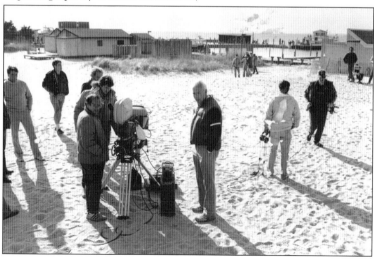

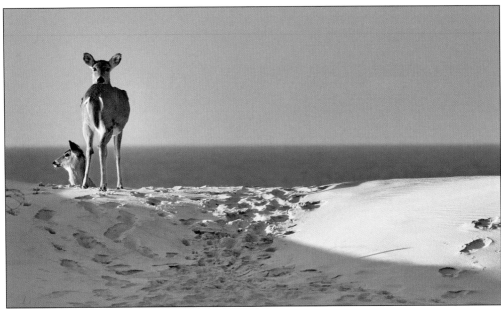

The rich bounty of nature that exists within the thin strip of the barrier island is one of the things that make Fire Island so special. Birds and insects fly the skies, marine life swims in the waters, and the narrow island supports an array of reptiles and mammals. As urban sprawl continues on Long Island, places like Fire Island have become a place of refuge for creatures like the white-tailed deer and red fox. Such animals are often at the center of controversy, but Fire Island is their home, too. (Photographs by Vicki Jaroun, Babylon and Beyond Photography.)

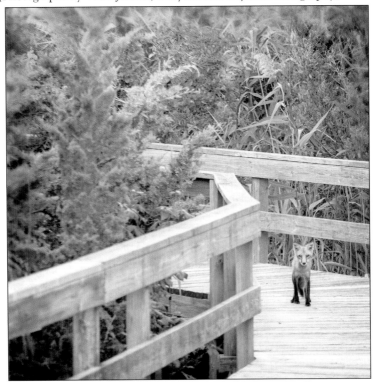

Four

PRICE OF PARADISE

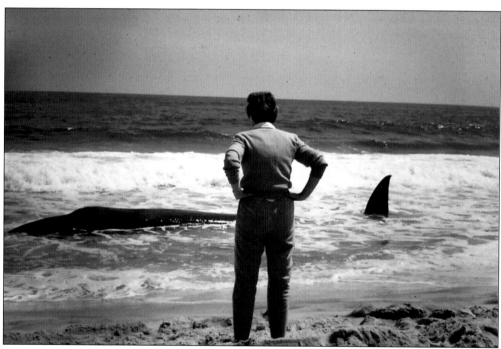

Amid the joys of living on a barrier island, sobering realities can also be brought to light. The ills of this planet wash up, and one cannot just look away or change the channel. Is it possible to love paradise just a little too much? Is it possible to be guilty of loving an island to death? (Courtesy NPS.)

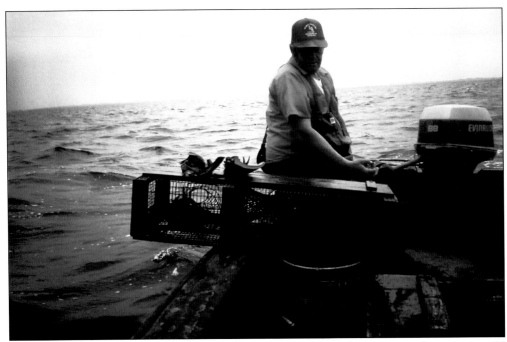

Clamming boats were once so plentiful in the Great South Bay that it was said a person could cross the bay by stepping aboard them and never touch the water. Between 1963 and 1976, the bay's annual harvest of hard-shell clams ballooned, from 154,386 to 700,365 bushels a year. Appetites could not be satisfied, nor such bounty sustained. By 2002, the Bluepoints Company of West Sayville, New York, ceased its clamming operations, putting independent baymen out of work. A cherished food source and way of life were in decline. Shown above is Fred Verity of Bay Shore, New York, and in the below photograph are Lenny Koch (left) and Bobby Marinaccio. (Both, courtesy Long Island Traditions collection.)

Overexploitation of marine resources is not the only reason that fishing numbers have diminished. The Great South Bay is now a drainage basin for almost 1.5 million residents of Suffolk County who live along the complex network of waterways throughout Long Island. The quest for greener lawns leads to fertilizer runoff that ultimately finds its way to the Great South Bay, creating nitrogen-infused algae blooms, robbing the bay of its ability to support life. Clam reseeding efforts make great photo-op gestures for local politicians, but they rarely take hold. While Suffolk County started passing runoff legislation in 2008, lobbyists with major fertilizer companies influenced these laws, which perhaps did not go far enough as a result. (Above, courtesy Cornell Cooperative Extension of Suffolk County Stormwater Program; below, courtesy NPS.)

Personal watercraft, such as Jet Skis, can have significant impact on wetlands and the bay environment. Noise, emissions, and damage to marsh vegetation are among the ecological concerns. In 2002, a federal Jet Ski ban was imposed at 21 national park properties, including Fire Island, but the ban was lifted in 2005 under public pressure. (Photograph by MaryLaura Lamount, courtesy NPS, William Floyd Estate.)

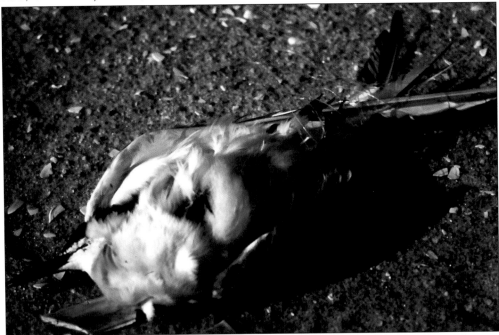

Perhaps no loss feels quite so pointless as that of a shorebird or marine creature succumbing to man's carelessness. This tern was killed after it became entangled in stray fishing line. Such accidents are often the result of terns following the trails of fishing boats and subsequently getting caught in nets. (Courtesy NPS.)

54

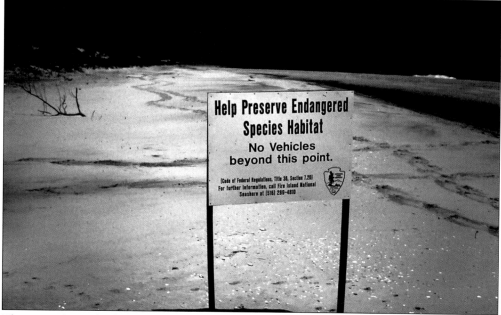

There may be no bird more vilified on Fire Island than the piping plover. Fire Island National Seashore has gone to considerable lengths to protect the bird, an endangered species, and its dune-nesting habitat. For essential service providers and year-round residents with driving permits, the bird represents hindered access to driving routes. The barring of portions of the beach to recreational purposes also contributes to the perception of the piping plover as an inconvenience among visitors and summer residents. FINS's efforts have achieved respectable success, with breeding pairs managing to fledge generations of new chicks each year, but this program has also led to friction with the public. (Both, courtesy NPS.)

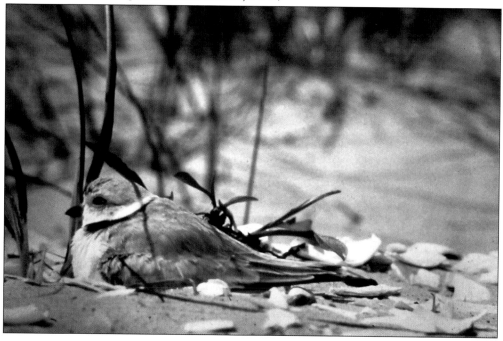

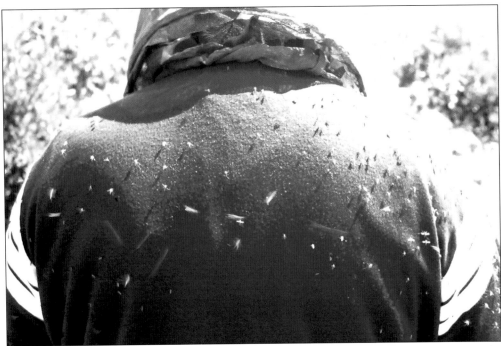

With an abundance of wetlands, Fire Island sees some of the highest mosquito concentrations in Suffolk County. With new insect-borne diseases in the 21st century, including West Nile virus, this can be the cause of concern, if not panic. Fire Island National Seashore has a "no spray" policy within areas under its jurisdiction unless a health emergency is declared. In the photograph below, rangers gather mosquito samples for testing at William Floyd Estate. Many residential communities opt for pesticide spraying as a matter of routine practice. Competing mandates effectively cancel each other out. Nobody wins. (Both, courtesy NPS.)

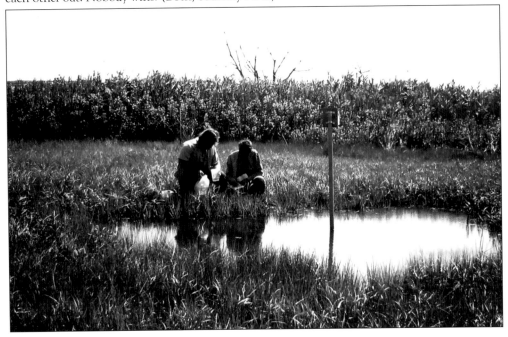

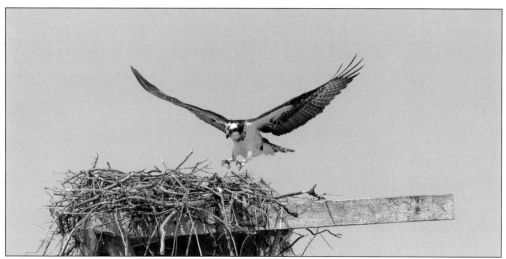

The problem with area pesticides is that they are indiscriminate. Regular applications will offer some relief, but at the expense of all that makes Fire Island's ecosystem rich and diverse: the dragonflies, praying mantises, reptiles, and amphibians. Resident nesting birds will lay egg clutches with thinner shells. The waters will yield tainted fish. Fire Island's food chain is affected, right up through what may come to the dinner table. As the mosquito's natural predators are also vulnerable to succumbing to these contaminating agents, greater quantities are required to do the job. The cumulative effects touch everyone. Pictured below with a baby turtle is 16-year old Alia Macri in Corneille Estates. (Above, photograph by Mike Busch, GreatSouthBayImages. com; below, photograph by Theresa Macri.)

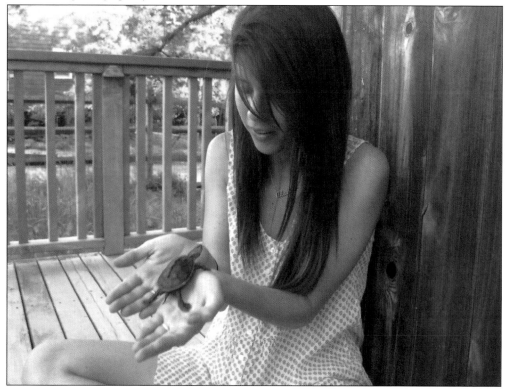

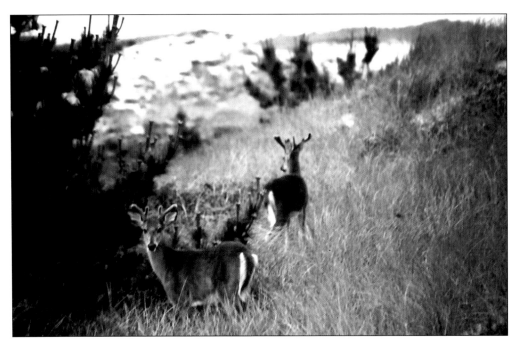

Sightings of white-tailed deer on Fire Island were once a rarity; by the 1980s, a population explosion was evident. Sightings were not just common, but ubiquitous. In partnership with the New York Department of Environmental Conservation, Fire Island National Seashore held an "experimental" deer hunt in 1989. Bow-and-arrow hunters were invited to the island, and specimens were analyzed to collect data. This did not go over well with some Fire Island residents; as in the 1960s, they protested. There were some arrests. The hunt was discontinued early. (Both, courtesy NPS.)

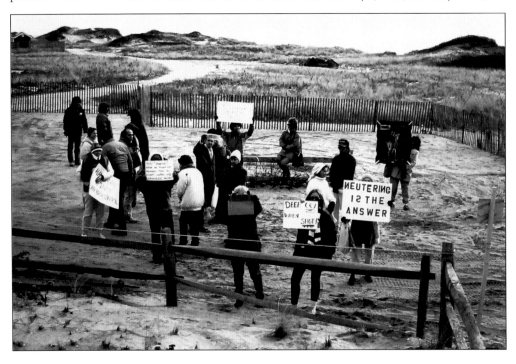

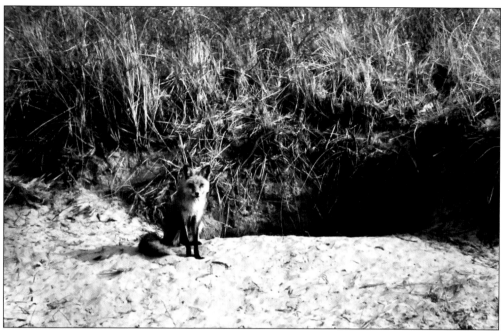

Fox sightings are not uncommon on Fire Island. The dens they dig can be found among dune swales. However, foxes are predators, and they will raid nests to feed their young. This is problematic when managing endangered shorebird species. Robert Moses State Park employees began trapping and euthanizing the animals in 2012, a move received with public outcry. "Foxes, crows, gulls, raccoons and feral cats always get the blame. The real culprits are people on ATVs, off-leash dogs, [and] beach erosion," wrote Frank Vincenti, director of the Wild Dog Foundation of Mineola, New York, in a letter to *Newsday* on February 7, 2012. Officials representing Fire Island National Seashore were quick to point out that the unpopular incidents took place on state-operated parkland not under its jurisdiction. (Above, courtesy NPS; below, photograph by Mike Busch, GreatSouthBayImages.com.)

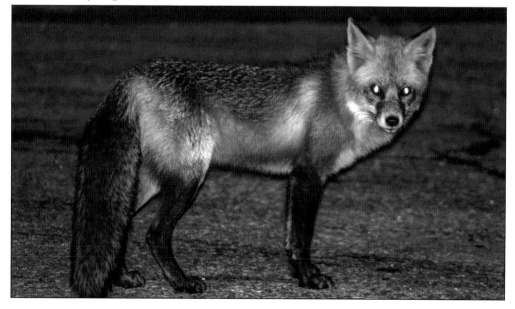

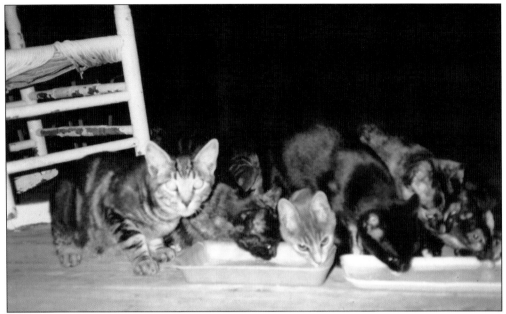

Feral cats are an issue in almost every part of Fire Island. Their presence is more complicated than vacationers leaving unwanted pets behind, although this is one important factor behind the problem. Many colonies have existed for generations, with the animals reverting to a wild state and breeding, further expanding their numbers. Life is a struggle for these creatures against the barrier island elements, especially during the harsh winter months. Arriving at humane solutions can be a difficult balancing act. Good Samaritans exist in every community, and they do what they can to help. But this, too, can be a thorny venture. (Both, courtesy Fire Island Animal Rescue.)

Quality-of-life concerns accompany the feral cat issue. Some residents regard the animals with compassion, while others see them as an unwanted nuisance. Being small predators, the cats keep the island's rodent population in check, but they can be a menace to birds. Studies reveal that habitat loss associated with the demands of housing construction and subsequent clear-cutting of foliage actually has a much greater impact on the birds within Fire Island's ecosystem than the cats ever could. But the cats, being visible, so often become the sole focus of blame. (Above, photograph by Sharon Fiyalka; below, courtesy Fire Island Animal Rescue.)

The lack of automobiles is one reason the bar scene thrives on Fire Island, which is a huge draw for tourism. With moderation, the nightlife can be an enjoyable aspect of the island. However, unruly behavior, vandalism, and, sometimes, more violent crimes have become real quality-of-life concerns in the summer season, when visitor population swells and temperatures rise. Local law enforcement can quickly become over-extended under these circumstances. Boating while intoxicated incidents on the Great South Bay have also increased in recent years, proving a threat to life and safety while straining Coast Guard and maritime police resources. (Photographs by Lani Aughenbaugh.)

On the evening of July 17, 1996, all 230 souls aboard TWA Flight 800 perished over the waters of Fire Island. This tragedy remains one of the deadliest aviation accidents within US territory. Years have passed, and conspiracy theories still abound. At Smith Point County Park, a polished black granite memorial poignantly remembers the victims. For the memorial, which was unveiled in 2002, designer David Busch took cues from the Japanese artist Hokusai, as peaking waves transform into birds taking flight on one side (above), while the names of the lost passengers and crew are inscribed on the other (below), with a panorama reflected back to the viewer. (Photographs by Kathryn Nagelberg.)

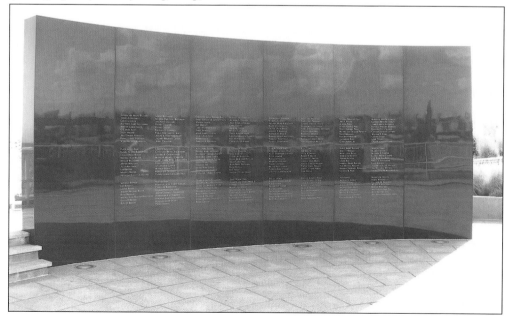

The introductory sentence of Public Law 88-587 of the 1964 FINS Enacting Legislation states that the national seashore is being created "for the purpose of conserving and preserving for the use of future generations certain relatively unspoiled and undeveloped beaches, dunes, and other natural features within Suffolk County, New York, which possess high values to the Nation as examples of unspoiled areas of great natural beauty in close proximity to large concentrations of urban population." Yet, there are still those who would seek to tame and sanitize Fire Island for their own advantage. In times of calm and plenty, it is all too easy to become forgetful. Real estate prices soared in the early 21st century. Yet, like the specter of a mysterious vessel in the fog, the unknown waited among the shadows. The forces of nature can be swift and relentless on a barrier island. (Photograph by Diane Abell, DustyDogDigital.com.)

Five

PARADISE LOST

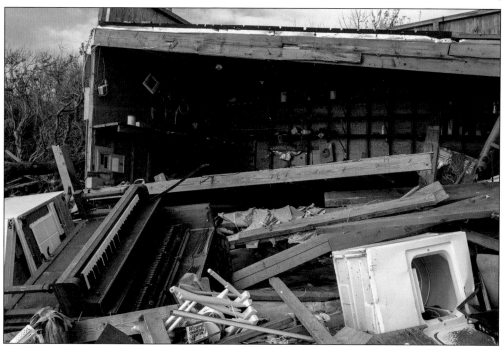

Like a somber concerto, Hurricane Sandy arrived on the shores of Fire Island on October 29, 2012. This would change everything. While the hurricane impacted much of the northeastern United States, Fire Island encountered the second-highest storm surge on Long Island, at 15 feet. The highest surge took place at Long Beach, New York. (Courtesy FEMA/Chris Ragazzo.)

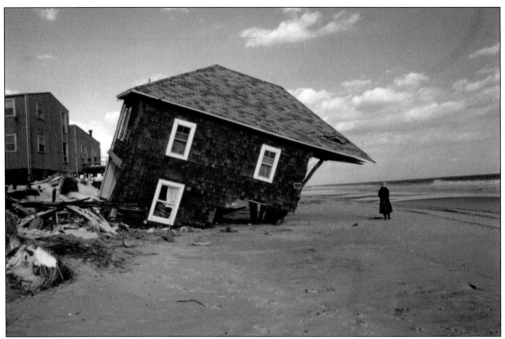

Storms are no stranger to Fire Island. Hurricane Gloria in 1985, the Halloween Storm of 1991, and countless nameless nor'easters are all part of Fire Island's collective memory. These events brought important reminders of nature's power. Fortification attempts made to stave the tides hold for only so long. In the undated photograph above, a beachfront house has been destroyed in Ocean Bay Park. Below, also in Ocean Bay Park, in the 1990s, sandbags reinforce the toe of a dune most likely created by a process known as "beach scraping." Beach grasses were planted in hopes they would take root to give the new dune strength. (Photographs by Helga Aschner.)

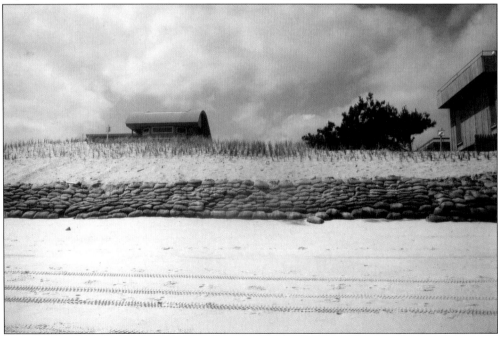

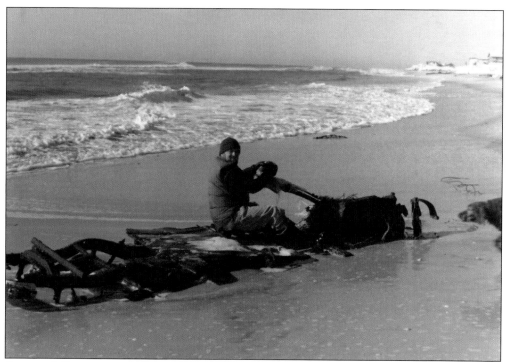

Storms of all sizes are common enough on Fire Island for the locals to sometimes make light of the subject. Above, John Schaffner of Ocean Beach takes a ride on a long-buried and rusted-out Ford Model A that resurfaced as a result of beach erosion that Hurricane Gloria brought in 1985. It is unlikely that he made it very far. Below, a summer flood in Ocean Beach's commercial district in the 1990s is an excuse for some rather interesting transportation arrangements. Bay flooding is often the result of squalls or heavy rains in combination with the full moon bringing up the bay tides. (Above, courtesy John Schaffner; below, photograph by Helga Aschner.)

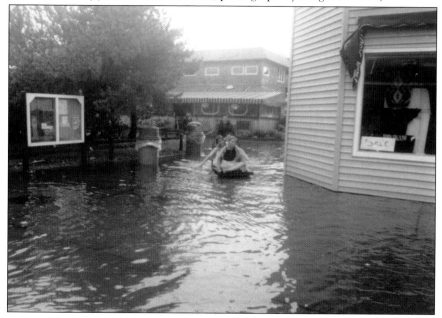

A nor'easter took hold of the Casino Restaurant (above) in December 1995. The beloved institution in Davis Park was washed out to sea in the raging tide. The proprietors wasted no time in taking command of the situation. A structure of similar design was built on Long Island and, as at the beginning of the 20th century, when buildings were routinely floated over to Fire Island, the new Casino traveled by barge (below). It was open for business by summer. The Casino became a symbol of the resilience and tenacity of Fire Islanders in the face of disaster. Rebuilding is what they happen to do best. (Below, photograph by Eagle Eye Aerial, Ronkonkoma, New York; both, courtesy Kristin Tully Downs, Casino Restaurant.)

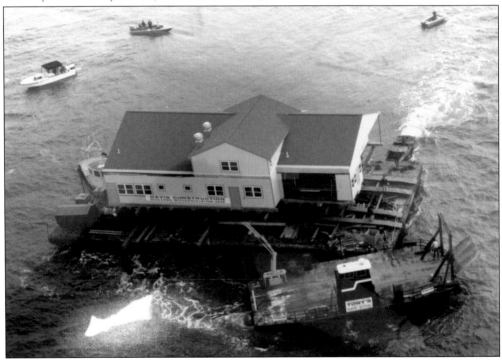

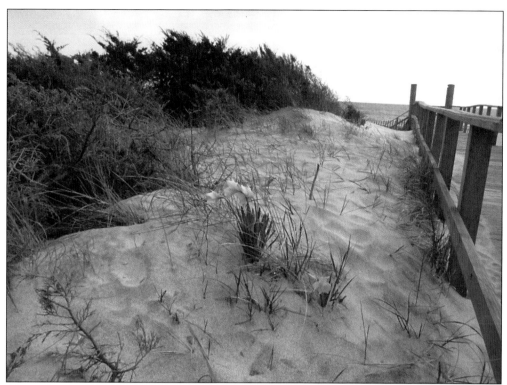

Above, hardy daffodils take root by a dune overpass on April 10, 2012. The same scene was photographed a year to the day after the earlier image below. It had been many years since a serious storm impacted Fire Island. Perhaps people were lulled into a false sense of security. Lesser events hyped by the media may be why more residents did not heed the warnings. But Hurricane Sandy was different. It was the largest Atlantic hurricane in diameter on record, with a wind-span of over 1,000 miles, hence the name Superstorm Sandy. By the time it reached the Northeast coast, it had been downgraded to a post-tropical cyclone, but it was still a force to be reckoned with. (Photographs by the author.)

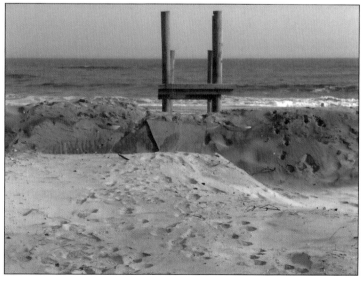

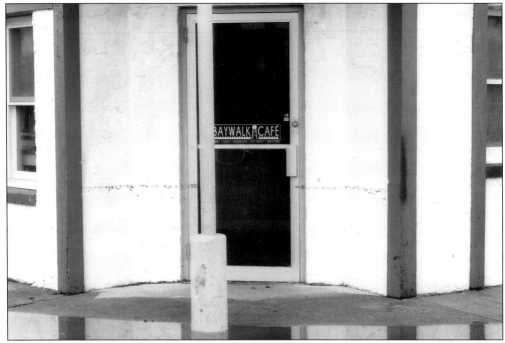

When it was safe to venture out the morning after Hurricane Sandy, the few Fire Island residents who had not evacuated found their island transformed. Infamous storms in prior years resulted in either beach damage or bay flooding, but Sandy brought both. Flooding was not measured in inches, but in feet, as the high-water mark at an Ocean Beach café indicates (above). Structures of all kinds were ravaged along the oceanfront (below). Even more disturbing, the dune line itself had migrated northward. Some parts of the island were hit harder than others, but none was spared. (Photographs by Frank X. Fischer.)

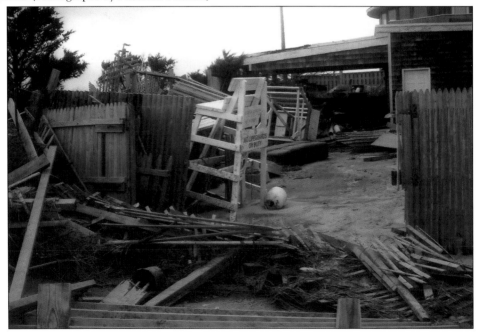

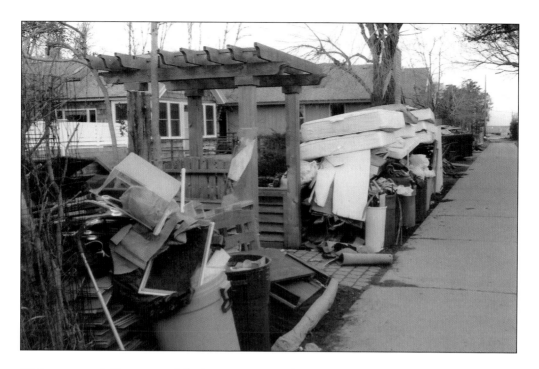

With a reported 80 percent of the houses on Fire Island experiencing some degree of flooding, spoiled items lined the streets for months. The above photograph shows such a scene on Ocean Road in Ocean Beach. The island had the appearance of being frozen in time, as areas with comparable damage in other parts of New York were much further along in the recovery process. The lack of traditional roadways made removal of so much refuse problematic. The US Army Corps of Engineers stepped in to organize an island-wide cleanup. Below, the USACE removes debris from Point O' Woods via a garbage barge. (Above, photograph by Frank X. Fischer; below, courtesy FEMA/Andre R. Aragon.)

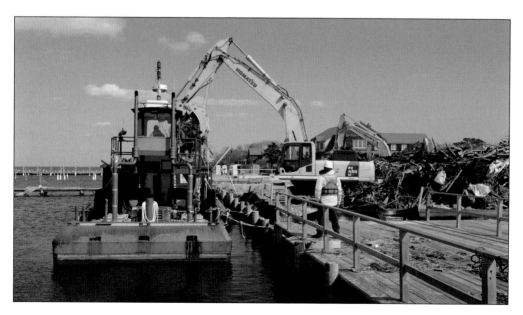

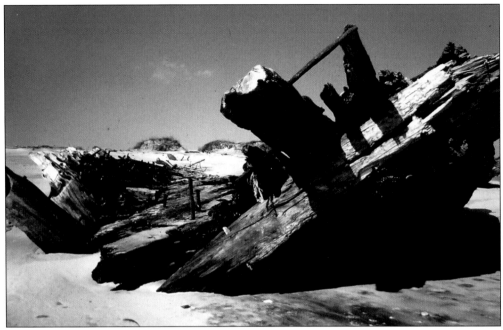

In the wake of Sandy, four miles east of Davis Park, the remnants of a vessel thought to be the *Bessie White* emerged, a reminder of Fire Island's maritime history. The four-masted, 200-foot-long schooner ran aground in a heavy fog a half mile west of Smith Point on February 22, 1922, while transporting coal from Virginia and Newfoundland. Over the years, tips of the wreckage entombed with the dune would appear after a harsh storm, as the above FINS file photograph from 1972 indicates. But the ship was never so fully exposed as it was 40 years later, as documented below by FEMA. (Above, courtesy NPS; below, courtesy FEMA/Chris Ragazzo.)

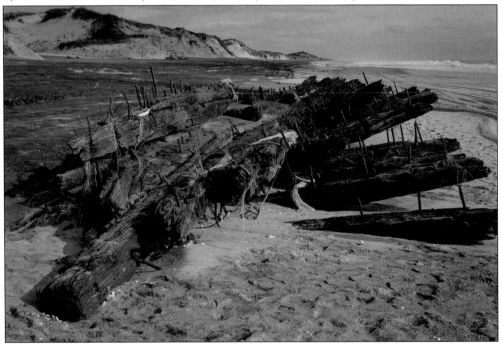

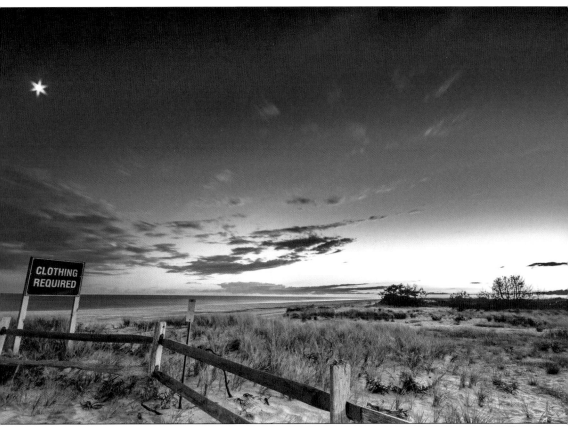

Another casualty of the storm was the nude beaches. As of February 5, 2013, it was officially announced that Fire Island National Seashore would begin enforcing New York State's law against public nudity. Reasons stated included an increase in inappropriate sexual activity as well as criminal behavior in recent years. And with the now diminished dunes, nude sunbathers were more visible from access points to the beach. While the nudists were a niche group of stakeholders, Lighthouse Beach attracted up to 4,000 visitors on its busiest days, making the reversal of the decades-old tradition a crushing blow to a dedicated faction of beach-lovers. "I will remember this day with clarity as the day in which what kept me here faded away into a memory," wrote Larry Jensen, publisher of *LightHouseBeachTimes.com*, in his farewell newsletter. However, not all beaches on Fire Island are under federal control. Nude sunbathing in the Cherry Grove and Fire Island Pines communities remains an option. (Courtesy Mike Busch, GreatSouthBayImages.com.)

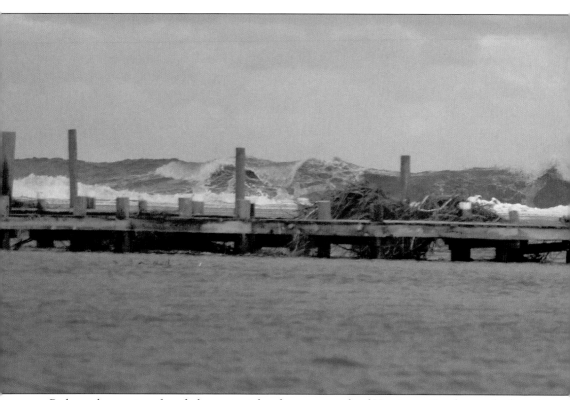

Perhaps the most profound change to take place as a result of Hurricane Sandy was the breach that emerged at Old Inlet, effectively severing Fire Island in two. (See map, pages 16 and 17.) As the breach took place within the Otis Pike Wilderness Area, a 1997 Breach Contingency Plan

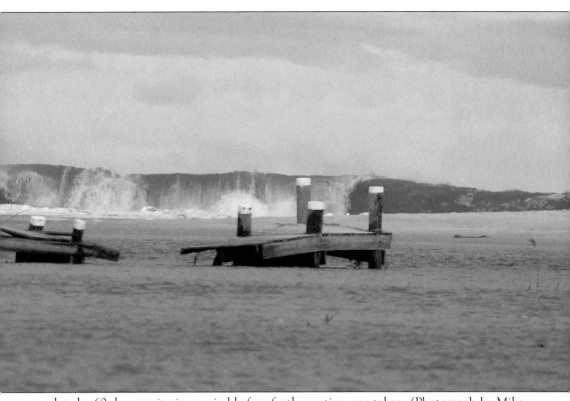

mandated a 60-day monitoring period before further action was taken. (Photograph by Mike Busch, GreatSouthBayImages.com.)

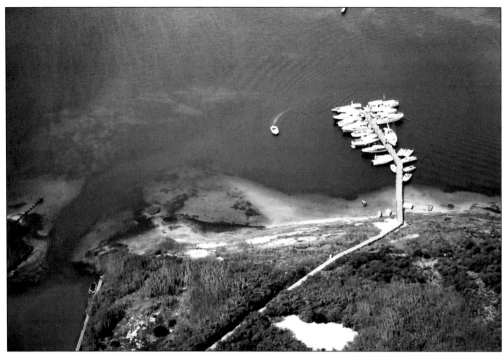

Old Inlet's namesake stems from the inlet once present in the same area during Revolutionary War times. It reportedly closed in the 1830s. The 1975 aerial photograph over Old Inlet (above) illustrates that this area was still a vulnerable location if a major storm were to happen again. American Indian tribes of the area named this phenomenon of non-permanent inlets *cupsogue*, recognizing it as part of the barrier island's existence. On February 27, 2013, the historic Pattersquash Gun Club, located on nearby Pelican Island (a small islet under FINS jurisdiction), lost the fight and washed out to sea (below). The breach that measured 108 feet across when first formed was now 1,171 feet and getting wider. (Above, courtesy NPS; below, photograph by Mike Busch, GreatSouthBayImages.com.)

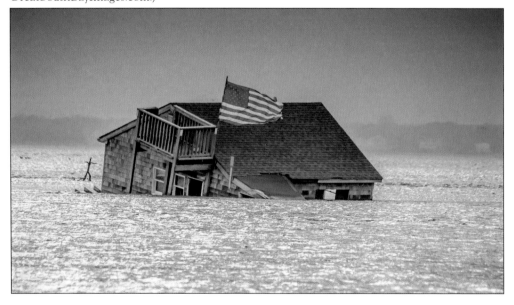

With most of the dunes now leveled, Fire Island's terrain became almost unrecognizable. In the brutal winter that followed, additional bay flooding over the next six months served to undo and frustrate any repair efforts. Politicians and media pundits began to call for the closing of the breach, claiming it was responsible for the repeated incidents. However, scientists and local environmental groups saw other dynamics at work in the Great South Bay and urged the public not to reach hasty conclusions. A new rift had been brought by the storm, this one involving the polarization of opinion. (Photographs by the author.)

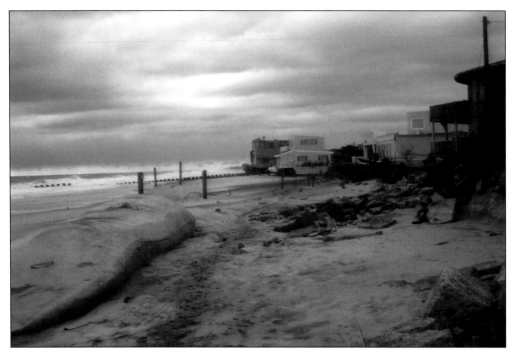

In the above photograph, at least two forms of obsolete beach-erosion control technologies are evident: the concrete groins constructed by Ocean Beach Village after 1962, visible along the horizon, and Geotube units installed in the 1990s, laid out like a great dead fish in the foreground. These measures proved insignificant if not detrimental after Hurricane Sandy. Was this storm a 100-year flood event or foreshadowing things to come? Had the much-dreaded day that the island would wash away finally arrived? Would the rebuilding of homes, communities, and infrastructure be as fleeting an endeavor as the Fitzgerald children pictured below building delicate castles in the sand? (Above, photograph by Frank X. Fischer; below, courtesy Mary Ann Dayton-Fitzgerald.)

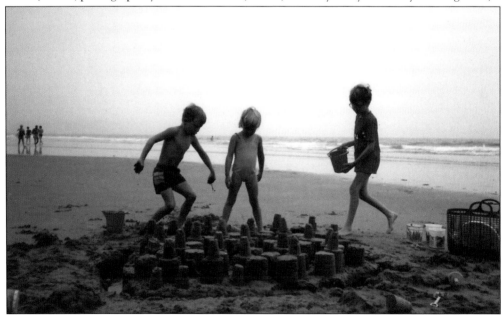

Six

REFLECTION

After sorrow and loss, where can an island go but forward? Not all of the pieces can be put back together, but fresh concepts can be envisioned. Sometimes, the boldest approach is a gentle hand, as well as the courage to tread lightly. (Photograph by Anne Gabriele, AnneGabriele.com.)

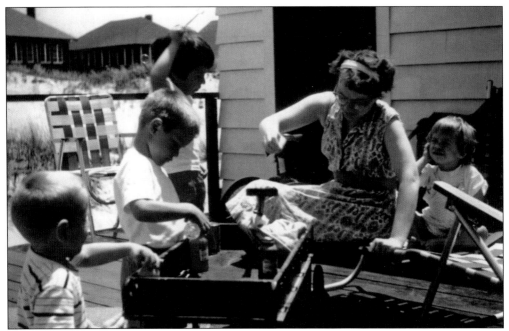

The serene image of Nancy Dwyer helping her children mix bubbles in 1963 may seem like a snapshot of a more innocent time, but this, too, was a summer fraught with uncertainty. Had construction of Robert Moses's highway been approved, the Dwyer home would have been slated for demolition, along with many others. (Courtesy Eileen Dwyer Larsen.)

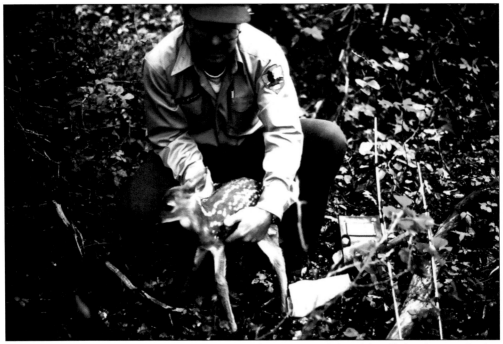

Fire Island is at its very best when compassion and respect is exhibited for all that lives and takes refuge there. Herein lies Fire Island's greatest strength and, perhaps, at least part of the answer for the its salvation. Its destiny goes hand in hand with this spirit. (Courtesy NPS.)

Fire Island is the place where people remember themselves when they were young, and where they will continue to feel young at heart for the rest of their lives. Memories are made here. Friendships are built here. It is this that keeps Fire Islanders' spirits here and why they always return. Pictured in the above photograph are, from left to right, Joey Abrams, Gilda Gross, Eddie Eaurer, Jonah Katz, Laura Silverman, and Jordan Glaubinger at the Fair Harbor dock. Below, a group of hikers holds an evening jam session on the back deck of the Appalachian Mountain Club's cabin retreat. (Above, photograph by Ellen Abramowitz; below, courtesy Appalachian Mountain Club collection.)

Growing up in Sayville, New York, artist Susan Brown draws on her impressions of the Great South Bay area for many of her works. The economy of detail is somewhat reminiscent of Milton Avery, but she captures the essence of Fire Island in a way all her own. As an autistic adult, Brown has created works featured in a number of Outsider Artist exhibitions in Vienna, Austria; Amsterdam, the Netherlands; and cities throughout the United States. Since 2002, she has been represented by Pure Vision Arts, a not-for-profit gallery dedicated to the mentoring of artists with developmental disabilities. (Both, courtesy Susan Brown.)

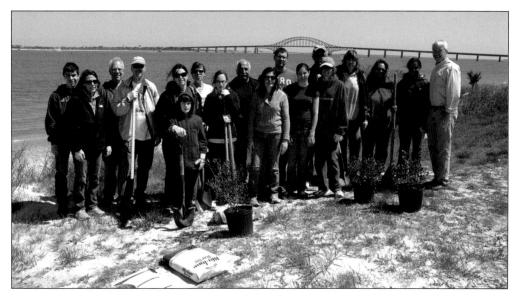

Volunteers at Robert Moses State Park are pictured with New York state senator Phil Boyle (far right) in May 2013. Organized planting of beach plum and bayberry along the dune line six months after Sandy was intended to inspire hope. How much these gestures will actually fortify the dune line in years to come has yet to be seen. (Courtesy the office of Sen. Phil Boyle.)

Workers from the US Forest Service were dispatched to Fire Island to remove fallen trees in the weeks following Sandy. Efforts by local fire departments and various response agencies were heroic. When the emergency teams were gone, however, Fire Islanders were left to wonder, what's next? (Photograph by the author.)

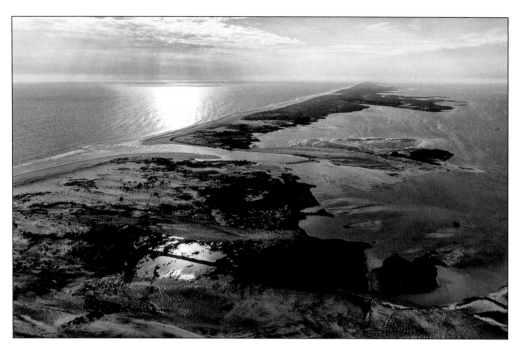

With the passing of Hurricane Sandy's first-year anniversary, the breach continues to flow strong. Oceanographers have determined the breach stable enough to classify as an inlet that will remain in place until further notice. Along with the inlet are signs of vitality that had been missing in the Great South Bay for many years. Cleaner waters have brought improved fishing and life again, including a passing harbor seal that stopped by for a visit (below). These are indicators of estuary health and hope that a long-ailing bay could be on the rebound. (Above, photograph by Diane Abell, courtesy NPS; below, photograph by Mike Busch, GreatSouthBayImages.com.)

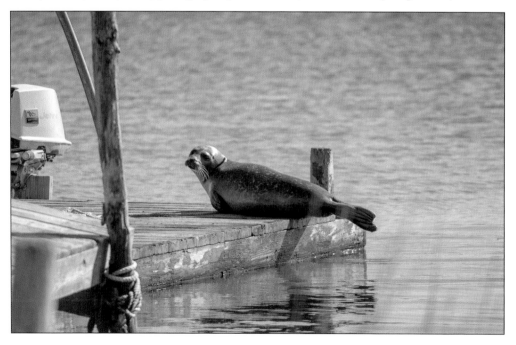

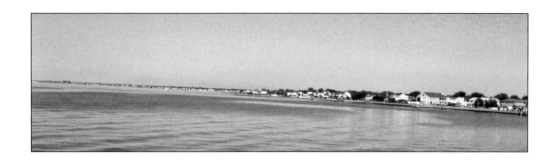

Not all parties are so quick to celebrate the benefits of the new inlet. The water-polluting factors are still there, thus, the root problem persists. Scientists and policymakers who take this less-popular position argue that allowing the inlet to remain open is just a cheap means to flush out the bay without addressing the true issues at hand, while possibly putting homes and neighborhoods along the south shore of Long Island in peril when another serious coastal storm arrives. Either way, making the wrong decision would have far-reaching consequences. (Above, photograph by Christopher Brennan, MD; below, photograph by the author.)

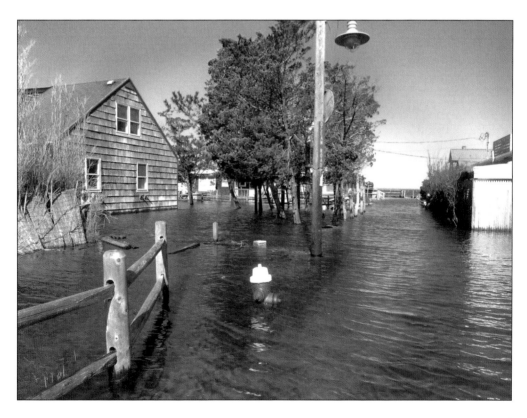

Perhaps one of the more novel concepts to come about in recent years is the idea that Fire Island be considered for United Nations Educational, Scientific and Cultural Organization (UNESCO) World Heritage Site status. Such sites include Stonehenge, the West Norwegian fjords, and Easter Island. It is a lofty ambition, for sure. To be nominated for such status, the place must be of "outstanding universal value" and must posses and embrace globally significant natural or cultural heritage. When stated in such terms, the idea does not sound all that far-fetched. (Above, photograph by Diane Abell, DustyDogDigital.com; below, photograph by Vicki Jauron, Babylon and Beyond Photography.)

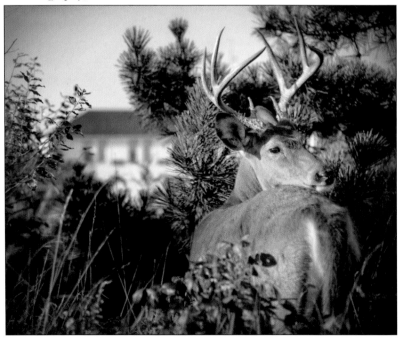

While a prestigious designation, what would be the tangible benefits if Fire Island were to gain UNESCO World Heritage status? Would such oversight on an international level prove to be just another layer of bureaucracy? Such questions must be weighed thoughtfully. However, it might be fair to say that while the technological approaches and opinions on how to best protect the beach have come and gone with time, the concept of preserving Fire Island for future generations has endured as a constant, and perhaps this in itself speaks volumes about the equation. (Above, photograph by Peter Schmidt, SWAMPonline.com; below, photograph by Christopher Mayer, FireIslandImages.com.)

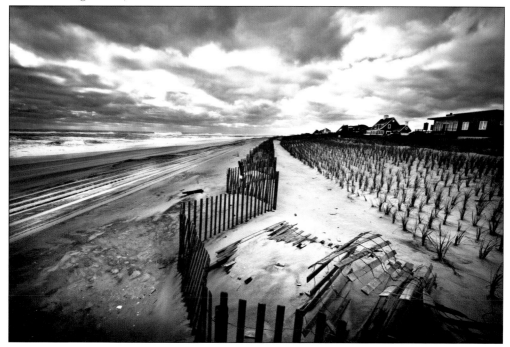

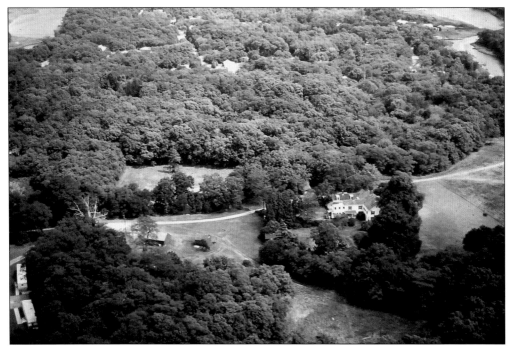

While situated on Long Island at Mastic Beach, William Floyd Estate is no less a part of Fire Island National Seashore, or the county's heritage. Visiting school groups will remember that one of the signers of the Declaration of Independence resided in Suffolk County, New York, because this place remains intact and open to the public. The lush estate grounds (above) also serve to remind visitors why the barrier island right across the bay is of such importance. To this day, descendants of Floyd may choose the property's ancestral burial grounds (below) as a final resting place. (Above, courtesy NPS/FINS, William Floyd Estate.)

Little Mary Farley, five, makes a friend on the beach by Ocean Bay Park in 1967. (Courtesy Mary Farley.)

In this photograph, Mary Farley is a radiant young mother wearing a red dress, standing in the doorway of Our Lady Star of the Sea Church in Saltaire. The occasion is the christening of her son Dillon Francis Donohue in 1990. Standing with her are Larry Donohue (far left), her sister Eileen Farley, and Mary's husband, David Donohue (far right). Fire Island draws its strength from the legacies of regular people. (Courtesy Mary Farley.)

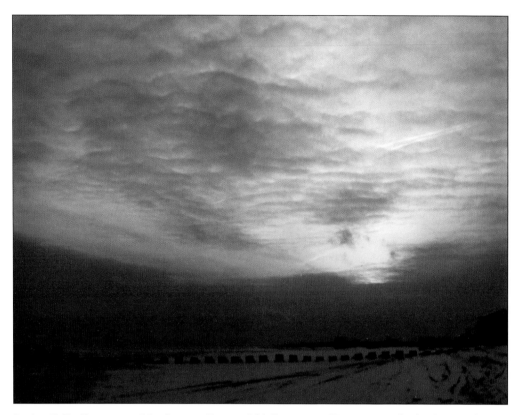

In the 1960s, Secretary of the Interior Stewart Udall cautioned Maurice Barbash, the president of the Citizens Committee for a Fire Island National Seashore, against showing pictures of sunsets when making his presentation before a congressional hearing. While Udall was prudently trying to avoid the pitfalls of clichés, maybe he was mistaken in this case. Sunsets may be universal, but some would argue that they are just a little more intense on Fire Island. The colors have the vibrancy of a more tropical climate, while taking on the rich, somber hues native to the Northeast coast. (Above, photograph by Douglas Meyer Jr.; below, photograph by Peter Schmidt, SWAMPonline.com.)

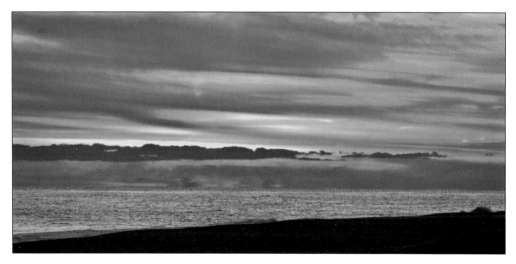

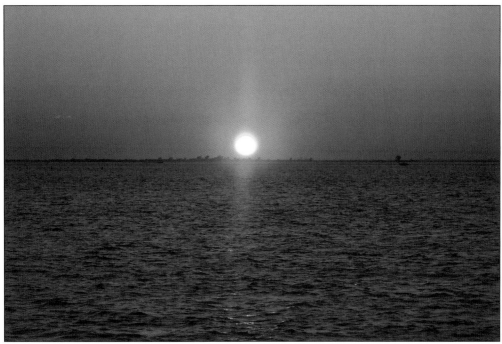

How Fire Island got its name continues to be an issue of friendly, if not spirited, debate. While the blazing sunsets were never a serious contender for the reason behind the name, perhaps it is fair to say that this natural phenomenon helped Fire Island's name endure long after antique maps were casually misread, or the wrecker and whaling fires ceased to burn. The light on Fire Island simply filters here like nowhere else, making a show of light and color that is never the same twice. The elements of sun, water, and air exist unobstructed. (Above, photograph by Christopher Brennan, MD; below, photograph by Danielle Hundt.)

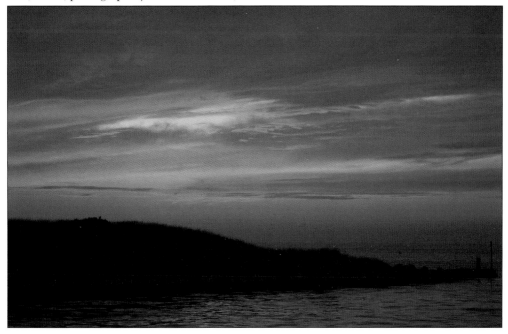

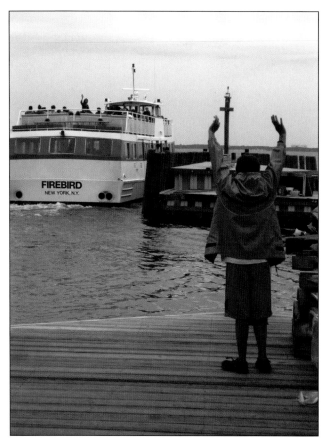

In the photograph at left, Zachary Jonas bids a loved one farewell as the *Firebird* departs from the Seaview ferry terminal in 2013. Following Sandy, the community of Seaview did not waste a moment, proceeding to restore its ravaged infrastructure as soon as possible and bringing back a sense of normalcy and safety to its visitors and residents. Decisive action by community leaders is perhaps the most essential component in the island's recovery, encouraging a healing process to take hold. The ties that bind are simple: No one wishes to abandon Fire Island, not just yet. This is their home. (Left, photograph by Seth Jonas; below, photograph by Christopher Mayer, FireIslandImages.com.)

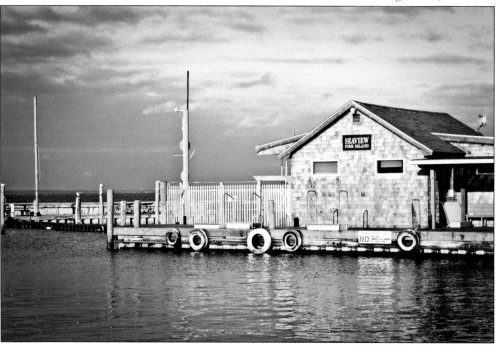

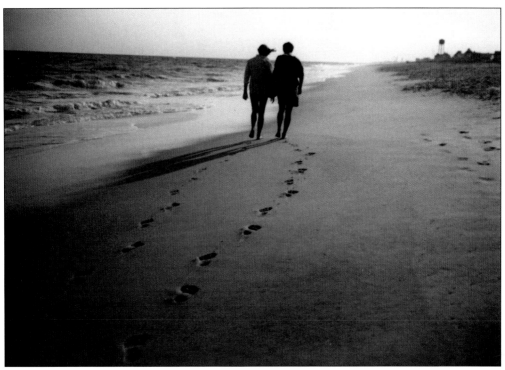

Unlike sturdy rock-strewn beaches that dot much of the Northeast, Fire Island's great expanse of fine-grain white sand along its ocean shore feels limitless and eternal. And yet, those who frequent Fire Island know that this sand is the most precious resource it has, and that it must be guarded with care. As ephemeral as footprints, the sand may also be taken by the wind or water at nature's will. Fire Island's destiny is predicated on finding the delicate balance between rebuilding what has washed away and knowing when it is time to yield. (Above, photograph by Lani Aughenbaugh; below, photograph by Vicki Jauron, Babylon and Beyond Photography.)

Father John Nosser (below) has presided over the congregations of Church of the Most Precious Blood in Davis Park and Our Lady of the Magnificat in Ocean Beach. With a tenure spanning decades, "Father Jack" knows his parishioners well. In coming to terms with loss after a great storm, he gently reminds them of Noah and the ark, and the vision of the dove returning with an olive branch after the waters receded: "As long as the earth endures, seedtime and harvest, cold and heat, summer and winter, day and night will never cease" (Gen. 8:22). (Above, photograph by Peter Schmidt, SWAMPonline.com; below, photograph by the author.)

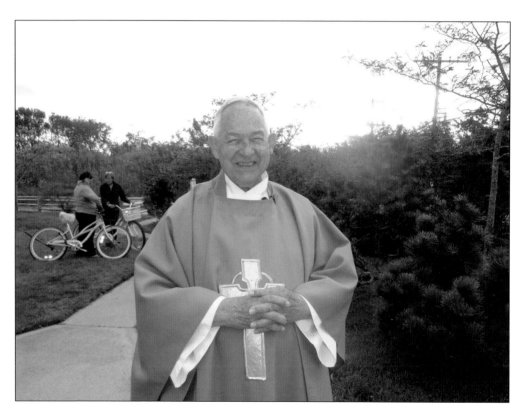

About Fire Island Animal Rescue

Fire Island Animal Rescue (FIAR) is dedicated to the health and welfare of animal residents of the Fire Island communities of Ocean Beach, Corneille Estates, Fire Island Summer Club, and Robbins Rest on a year-round basis. FIAR was formed during the 1980s in response to the expanding feral cat population due to pets left behind by vacationers, surviving their deceased owners, or who were stowaways on fishing boats. With the patronage of Brenda and Dr. Kenneth Luckow, DVM, FIAR became a New York State charitable organization in 2010 and was awarded 501(c)3 status the following year. Management of the feral cat colony through the practice of trap, neuter, and release remains its primary mission, but the organization will come to the aid of any sentient creature in need via direct response or agency networking. Visit FIAR's Facebook page (www.facebook.com/FireIslandAnimalRescue) or contact the group at Fire Island Animal Rescue, P.O. Box 276, Ocean Beach, NY 11770.

DISCOVER THOUSANDS OF LOCAL HISTORY BOOKS
FEATURING MILLIONS OF VINTAGE IMAGES

Arcadia Publishing, the leading local history publisher in the United States, is committed to making history accessible and meaningful through publishing books that celebrate and preserve the heritage of America's people and places.

Find more books like this at
www.arcadiapublishing.com

Search for your hometown history, your old stomping grounds, and even your favorite sports team.